OLD MASTER DRAWINGS

FROM AREA COLLECTIONS

BARRY WIND

WITH

JOSEPH RUZICKA

MILWAUKEE ART MUSEUM

1997

Milwaukee Art Museum
April 18—June 29, 1997

This exhibition and catalogue are made possible by the generosity of Helen Peter Love.

Published by the Milwaukee Art Museum, Milwaukee, Wisconsin
First edition

ISBN: 0—944110—79—7 (paper)

Library of Congress Catalog Card Number: 97-71384

Edited by Sheila Schwartz
Design and production by Gene Felsch, Milwaukee Art Museum
Films, color separations, and printing by Master Litho, Appleton, Wisconsin

Cover: Ferrau Fenzoni, *Study of a Seated Nude*, ca. 1590 (detail of Pl. 45)

CONTENTS

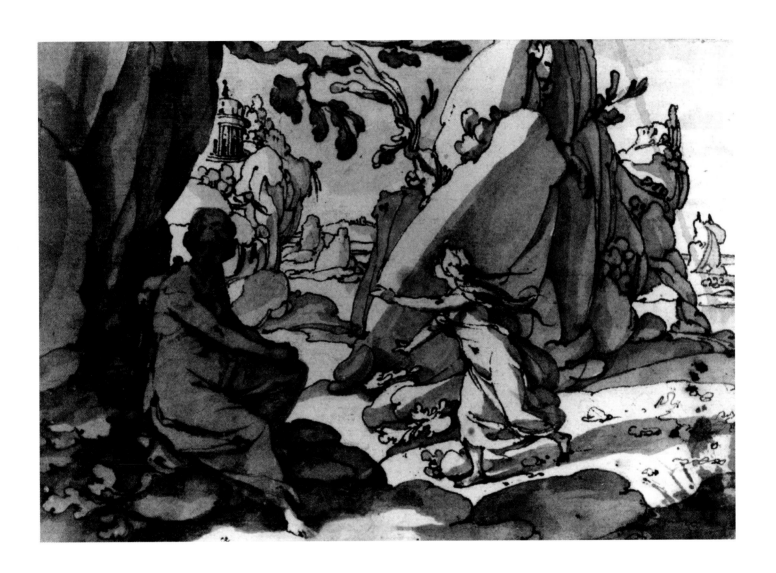

1. **Andrea Boscoli** (Italian, 1553/60-1606)
Armida Abandoned by Rinaldo, ca. 1600
Pen and brown ink with brown and gray wash over red chalk, on buff laid paper
5 7/8 x 8 7/16 in. (14.9 x 21.4 cm)
Milwaukee Art Museum; Max E. Friedmann—Elinore Weinhold Friedmann Bequest M1954.13

FOREWORD

This volume is published on the occasion of the exhibition "Old Master Drawings from Area Collections," held primarily to focus on and assess the Old Master drawing collection of the Milwaukee Art Museum. More than a half-century old, this part of the Museum's holdings has unjustly received scant attention until relatively recently. When I arrived at the Museum as Chief Curator in 1980, I sensed that there was an important core group of drawings—Old Master, 19th-century, modern and contemporary—and set about examining them in a variety of survey exhibitions: "Master Drawings from the Permanent Collection" (1981) and "Two Centuries of American Drawing from the Permanent Collection" (1985), both curated by myself, with the assistance of Verna Curtis, Associate Curator of Prints, Drawings, and Photographs, and "The Draughtsman's Process," organized in 1987 by James Mundy, then the Museum's Chief Curator. More recently, two other exhibitions have furthered the investigation of our permanent collection of drawings: "From Gainsborough to Pearlstein: A Decade of Drawing Acquisitions" (1990), also organized by Mundy, and "Abstract Expressionism: Works on Paper from the Permanent Collection" (1993), curated by Dean Sobel, Curator of Contemporary Art, a selection that also included prints.

The present exhibition continues this process and takes it to the next logical step, an intensive, critical look at a specific portion of the collection, the drawings, European and American, executed before 1800. I am pleased that a significant number of our drawings hold up well with pieces from some of the premier collections in the area, indeed, the country, namely those in The Art Institute of Chicago and the Elvehjem Museum of Art, University of Wisconsin—Madison. This exhibition inaugurates a series of exhibitions that puts portions of Milwaukee's permanent collection of drawings under intense scrutiny, identifying strengths and areas to address. An exhibition of 20th-century drawings is already on the schedule, with others under discussion. This sort of focus and reassessment can only strengthen the institution.

A second major impetus for organizing this exhibition is to present to the Museum's audience what is to most of them a new area of inquiry. Generally, the Museum's programming deals with Old Master and 19th-century *paintings*, photogra-phy, and modern and contemporary art in all media. Rarely, and then only in loan shows, have we addressed Old Master drawings in such a focused manner, and never using works from our collection. I hope that this show will spur a new enthusiasm in many of our viewers and supporters.

A project of this magnitude necessarily requires the hard work and vision of many people. My deepest thanks go Helen Peter Love, who so very generously underwrote the costs of the exhibition and catalogue, and introduced new people to the Museum. She made possible a most important enterprise.

I am most grateful to the private collectors lending to the exhibition, notably an anonymous collector, as well as Esther Leah Ritz, who has been so generous to the Museum for so many years, and Jeff Soref, who recently initiated what I am sure will be a long and beneficial relationship with the Milwaukee Art Museum. I extend my sincerest thanks to the museums that so generously lent works to the exhibition: The Art Institute of Chicago; the Elvehjem Museum of Art, University of Wisconsin—Madison; and The Patrick and Beatrice Haggerty Museum of Art, Marquette University, Milwaukee.

This exhibition and catalogue mark another milestone in the Museum's relationship with Barry Wind, Professor of Art History, University of Wisconsin—Milwaukee, guest curator of the show and author of the essay in this volume. Over the years, he has scrutinized our collection, lectured to our various constituencies, sent outstanding interns to work for us, and currently sits on our Print and Drawing Acquisition Subcommittee. I am deeply grateful to him for what he has done, and thank him in advance for his future contributions.

Special thanks should be extended to Joseph Ruzicka, Curator of Prints and Drawings, who conceived this exhibition and publication, and collaborated with Wind to see them to completion. His dedication to and enthusiasm for drawings of all kinds provides a most important direction for the future of the Museum's collection and programming.

Russell Bowman
Director

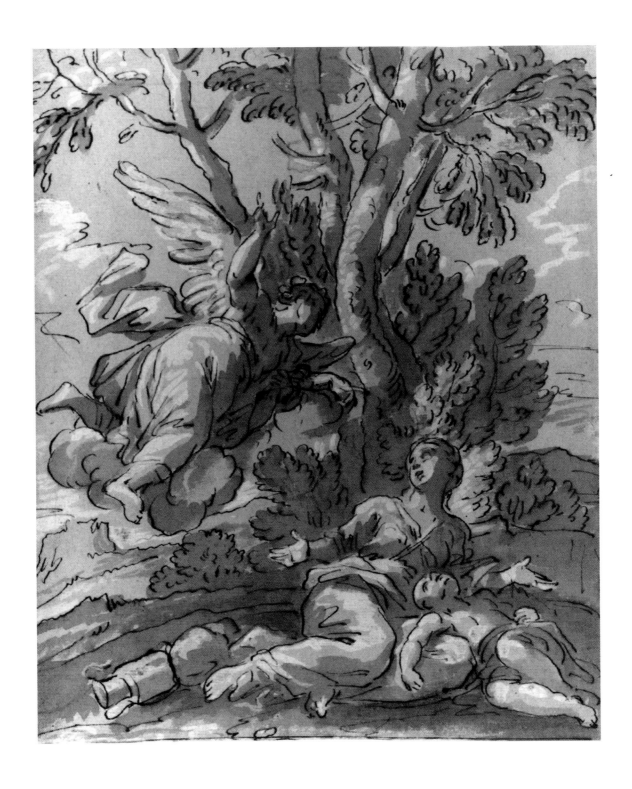

2. **Lodovico Cardi**, called **Il Cigoli** (Italian, 1559-1613)
An Angel Visiting Hagar and Ishmael in the Wilderness, late 16th century
Pen and brown ink with brown wash and lead white heightening, with pale-blue ground, on cream laid paper
12 3/8 x 10 7/16 in. (31.4 x 26.5 cm)
Milwaukee Art Museum; Max E. Friedmann—Elinore Weinhold Friedmann Bequest M1954.26

INTRODUCTION
AND ACKNOWLEDGMENTS

When the Layton Art Gallery, a predecessor of the Milwaukee Art Museum, was founded by Frederick Layton in 1888, the permanent collection consisted of contemporary painting and sculpture by the likes of Winslow Homer, Eastman Johnson, Frederic, Lord Leighton, James Jacques Tissot, and Gaetano Trentanove. It was not until Layton's gift in 1916 of thirty 19th-century American and English watercolors by Samuel Colman, William Henry Hunt, and others that the collection had any works on paper. In the 1930s, Dr. Ernest Copeland made a gift to the Milwaukee Art Institute (the other predecessor of the Museum, originally founded as the Milwaukee Art Association in 1888), in the form of funds for paintings and some of its first drawings, including purchases of watercolors by Stuart Davis and George Grosz.

For the next two decades, drawings and watercolors, mostly modern, slowly made their way into the collections of the two institutions. It was not until the 1943 and 1950 gifts to the Institute from the Austrian-born Mrs. Albert T. Friedmann that Old Masters—here defined as executed before 1800—entered a Milwaukee public collection; two of Mrs. Friedmann's six drawings, including the Florentine 16th-century red chalk *Head of a Woman* and the Roman 16th-century double-sided *Massacre of the Innocents*, are in the present exhibition.

A major gift of Old Master drawings, which to this day forms the core of that part of the collection, was included in the 1954 bequest to the Milwaukee Art Institute of Max E. and Elinore Weinhold Friedmann. Max Friedmann, the son of Mrs. Albert T. Friedmann

and a trustee of the Institute, gave fifty-seven drawings, among other works. It appears that the Friedmanns, mother and son, bought most of their drawings in Germany or Austria, since the information written on the original mats was in German. One curious consequence of this was that until recently, many of the drawings given by the Friedmanns, even the Italian works, were catalogued in Museum records with German titles.

A 1955 insurance appraisal for the Institute's entire collection listed 214 drawings (both Old Master and contemporary), 142 watercolors (mostly contemporary), and 18 pastels (mostly 19th century and contemporary). In 1957, the Layton Art Gallery and the Milwaukee Art Institute merged to form the Milwaukee Art Center, which assumed the designation of Museum in 1980. No inventory for the newly formed Center exists, but today the drawing collection numbers 860 works, including 80 Old Masters.

Since the mid-1950s, the Old Master drawing collection has grown fitfully, relying entirely on the generosity of patrons such as Richard and Erna Flagg, who in 1961 contributed two drawings by Benjamin West; the family of Isabelle Miller, who in 1971 donated a Thomas Gainsborough landscape; Robert and Virginia Krikorian, who in 1980 gave a portrait of an officer attributed to Henry Raeburn; and the Fine Arts Society and various donors, who together in 1990 purchased a design for a monument by Federico Zuccaro. The future growth of the collection is ensured in part through the promised gift of Esther Leah Ritz, which includes several important Old Master drawings.

As described in Russell Bowman's foreword to the present catalogue, beginning in the early 1980s, several exhibitions examined the general holdings of the Museum's collection of drawings. Building on the achievements of my predecessors, I am taking this progression of exhibitions to the next logical step by embarking on a series that focuses on very specific aspects of our holdings.

Therefore, the primary purpose of this exhibition and catalogue is to critically appraise the Old Master drawing collection of the Museum and to see how the best works measure up to outstanding works from major collections, notably, The Art Institute of Chicago and the Elvehjem Museum of Art, University of Wisconsin—Madison. While a number of Old Master drawing scholars—including Harold Joachim, Alfred Moir, Konrad Oberhuber, and James Watrous—have studied the collection and offered either reaffirmations of authorship or reattributions that were duly recorded in the files, this project marks the first time that a far-reaching examination has been conducted in public. Now that the collection is in play, some may take issue with our attributions and identifications, and we welcome such discussion, for our work is far from over. Any information that others can bring to bear on the collection only clarifies and enriches our holdings.

This projected series of focused investigations will culminate in a scholarly catalogue that presents the most important drawings in the Museum's collection, from the mid-16th century to the present. While I have a firm grasp of the quality and range of the American and European drawings from the 19th and 20th centuries, the situation of the Old Masters was unclear to me. Now, however, thanks to the efforts of guest curator Barry Wind, the twenty-nine finest drawings in the permanent collection (and six promised gifts) have been identified and recatalogued, providing a solid foundation for the growth of the Old Master collection. It is hoped that this exhibition will encourage collectors and students in the community to come forth and share with us their enthusiasm for the subject.

An undertaking of this nature is necessarily the result of the efforts of many people. Foremost, I am deeply grateful to Helen Peter Love, who so very generously underwrote the costs of the exhibition and catalogue and who gave much vital support and advice. In her enthusiasm for the project, she brought a number of new faces to the Museum, chief among them Owen Perry, of Midland Paper Company, Milwaukee, who generously helped to defray the costs of this publication.

For parting with works that have become essential companions in their lives, I am indebted to the generosity of Esther Leah Ritz, Jeff Soref, and an anonymous collector. For their dedication to and involvement in the project, I extend my deepest thanks to my colleagues from lending institutions: Curtis Carter, Director, The Patrick and Beatrice Haggerty Museum of Art, Marquette University, Milwaukee; Suzanne Folds McCullagh, Curator of Earlier Prints and Drawings, The Art Institute of Chicago; Andrew Stevens, Curator of Prints and Drawings, Elvehjem Museum of Art, University of

Wisconsin—Madison. Special thanks go to Phoebe Lewis for bringing an influential audience to this exhibition.

It has been a distinct pleasure and valuable learning experience to collaborate with Barry Wind, Professor of Art History at the University of Wisconsin—Milwaukee. In addition to writing the essay in this volume—and in the process, reattributing many of the Milwaukee Art Museum drawings—Wind visited all the lenders with me and molded the checklist of the exhibition. Thanks to him, the Museum now has a clear understanding of the quality and range of its Old Master drawing collection.

In the preparation of the catalogue, Sheila Schwartz provided sensitive and insightful editing.

The realization of this entire project has touched nearly every department in the Milwaukee Art Museum. Without the support of the Museum's Director, Russell Bowman, and Executive Director, Christopher Goldsmith, this project could never have been completed. Christine Fritsch-Hammes, Curatorial Intern, performed a yeoman's job. She recatalogued drawings, compiled checklists, handled loan and reproduction correspondence, researched grant opportunities, and prepared much of the back and front matter for this volume with exemplary speed and accuracy. Much of the excellence of this project is due to her efforts. Terry Marvel, Curatorial Assistant of Prints, Drawings, and Photographs, supervised the recataloguing of the drawings, and provided many insights and much support and advice at critical times. Jane O'Meara, Administrative Assistant, oversaw and coordinated the many difficult details in a timely and professional manner.

Jim deYoung, Senior Conservator, conserved and prepared several of the drawings in the Museum's collection, and answered many vexing questions regarding materials and media. He was ably assisted by Mark Dombek and Terri White. Together, we devised new standard framing for the Museum's Old Master drawings.

Leigh Albritton, Registrar, expertly arranged for and oversaw the shipping of drawings from all the lenders. Dawnmarie Frank, Assistant to the Registrar, coordinated the photography of the Museum's drawings, and Larry Sanders shot the photographs. Gene Felsch, Designer, designed this beautiful publication and produced an elegant installation. Larry Stadler, Facilities Manager, and his crew of John Dreckmann, Joe Kavanaugh, Dave Moynihan, and John Nicholson hung and lit the exhibition in their always efficient manner.

Once again, Barbara Brown-Lee, Director of Education, marshaled her dedicated corps of docents to do their usual marvelous job of teaching and interpreting the material for groups of visitors to the Museum. Dedra Walls, Coordinator of Media, wrote perceptive and informative text panels for the show.

Finally, I give heartfelt thanks to Susan Fancher, who has lived through many such projects and I am sure anticipates many more.

Joseph Ruzicka
Curator of Prints and Drawings

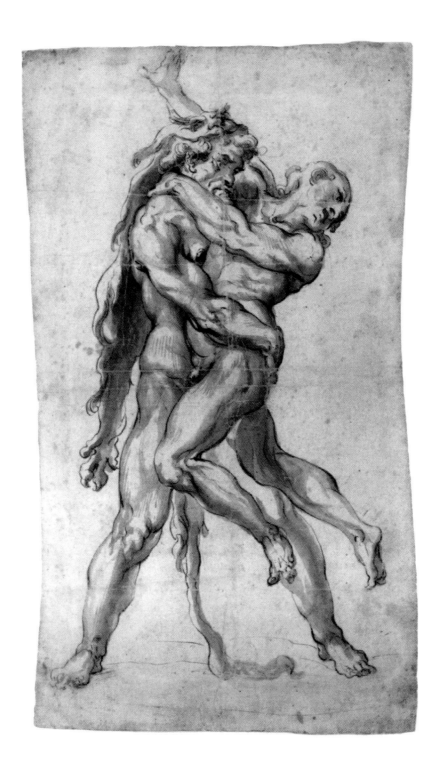

3. Attributed to **Gregorio de Ferrari** (Italian, 1644-1726)
Hercules and Antaeus
Pen and brown ink with brown wash over graphite, on cream laid paper
15 7/8 x 9 1/4 in. (40.3 x 23.5 cm)
Milwaukee Art Museum; Max E. Friedmann—Elinore Weinhold Friedmann Bequest M1954.19

"IN THE SIGHT OF BEAUTIFUL DRAWINGS": THE ART OF OLD MASTER DRAFTSMANSHIP

Barry Wind

In his handbook of advice, *De veri precetti della pittura* (*The True Precepts of Painting*), published in 1587, the art theorist Giovanni Battista Armenini counseled the aspiring artist to draw "everyday without fail" since drawing was "painting's foundation." Indeed, drawing traditionally has been viewed as fundamental for the artist. As early as the 14th-century, Cennino Cennini's handbook on artistic practice, *Il libro dell'arte* (*The Book of Art*), advised: "Do not fail, as you go on to draw something every day, for no matter how little it is it will do you a world of good." The great Leonardo da Vinci treasured drawings, saving them as visual records and using them as images to spur his fertile imagination. His extensive production of drawing was noted as early as 1518 in the *Libro di Antonio Billi,* wherein Leonardo is said to have "made numerous marvelous drawings." Drawing was in fact enshrined as an essential part of studio education. In the late 16th century, the prestigious academy established in Bologna by Annibale, Agostino, and Lodovico Carracci held drawing competitions, with a prize awarded to the best draftsman. In the 17th century, the gifted Gianlorenzo Bernini was viewed as unique by virtue of his skill as a draftsman. His biographer, Filippo Baldinucci, remarked:

> Cavalier Bernini was most singular in the arts he pursued because he possessed in high measure skill in drawing. This is clearly demonstrated by the works he executed in sculpture, painting, and architecture, and by the infinite number of his drawings....I would be at a loss to name a contemporary of Bernini who could be compared with him in that skill.

And Federico Zuccaro, whose study for the tomb of Ferdinando de' Medici is in the exhibition (Pl. 59), exalted drawing as divine. In his treatise on aesthetic principles, *L'idea de' pittori, scultori et architetti* (1607), Zuccaro viewed "disegno" ("drawing") as an anagram of "vero segno di dio in noi" ("the true sign of God within us").

Drawing was revered north of the Alps as well. When describing his *Allegory of War*, now in the Palazzo Pitti, Rubens considered drawing as a paradigm of culture and beauty. Thus the frenzied Mars crushes a drawing and a book, symbolizing the brutal irrationality of war. "If I remember correctly," Rubens wrote, "you will find on the ground under the feet of Mars a book and a drawing on paper to indicate that he tramples on literature and on other things of beauty." Rembrandt's pupil, Samuel van Hoogstraeten, declared: "If you want to ascend to the art of Painting, you have to climb up by Drawing," since without drawing "painting is not only defective, it is dead and absolutely nothing." The young artist was counseled to draw assiduously, copying prints and other drawings, and thereby learning a good manner. The Dutch theorist and painter Gerard de Lairesse, in his

Grondlegginge ter Teekenkonst (The Principle Rules of Drawing) of 1701 reiterated the significance of drawing for the ambitious artist.

But drawing was not only an intrinsic facet of artistic practice for pupil as well as master. Drawing resonated with multivalent implications. Artistic originality, for example, was a significant aspect of drawing. Thus the well-informed Vasari recounts that Michelangelo burned many of his drawings in order to prevent future generations from replicating his creativity. And the appreciation of drawing, admired as a vivid, personal, and private expression of the artist, was also a mark of the cultivated connoisseur. The learned Count de Caylus affirmed this in a public lecture delivered to the French Academy in 1732. The "great man is formed not only by the gifts of nature," but also by "the sight of beautiful drawings."

This exhibition of Old Master drawings corroborates all these conceits in a wide range of subject matter and techniques from different countries. Among the works are William Gilpin's evocative English landscape, as romantic as Wordsworth's poetry (Pl. 9); a highly finished study of a goat nursing two faun children for the *Marriage of Cupid and Psyche* at the Palazzo del Te (1528) by Raphael's prized pupil Giulio Romano (Pl. 49); a rapid sketch of St. Jerome, a favorite subject of the Venetian artist Palma Giovane (Pl. 52); and a delicate portrait attributed to the Scottish artist Henry Raeburn (Pl. 10). But whatever the medium—chalk, pen and ink, pastel—or whatever the subject, the drawings confirm the ideas of the Count de Caylus concerning the pedagogical importance of drawing. And not only do these works educate us through their sometimes recondite iconography, but they also reveal much about the artistic process. The drawing, intimate and personal, often records the private first thoughts of the artist.

Some of the drawings on exhibition were clearly used as points of departure for finished paintings. For example, Luca Cambiaso's *Meeting of Numa Pompilius with the Nymph Egeria at the Holy Well* (Pl. 41), a story derived from Livy, who recounts Numa's assistance in founding the early religious institutions of Rome, doubtless served as a preliminary sketch for the 1565 painting of this theme in the Palazzo Terralba in Genoa, part of a group of scenes from Roman history. The dynastic pretensions of the Terralba family were satisfied through association with such a pious Roman leader. Cambiaso's vigorously drawn figure of a prophet, another work in the exhibition (Pl. 42), can be linked to his paintings in the church of San Matteo in Genoa, dated 1559.

Other drawings served as templates for engravings or etchings. The carefully drawn *Abigail* by the 16th-century Dutch artist Maerten van Heemskerck was used for an engraved image of this Old Testament heroine, part of a series of six Virtuous Women (Pl. 13). The pinpricks used to transfer the image to a metal plate are still visible. Some drawings were ultimately intended for book illustrations. Jean-Baptiste Oudry's splendid red chalk drawing of hunting trophies, a roe and a heron suspended from a tree, dated ca. 1721, was used as a frontispiece to a treatise devoted to hunting (Pl. 25). The meticulous drawing of hands by the 18th-century Dutch artist Jan Josef Horemans the Elder may have been designed for an instructional manual for aspiring artists (Pl. 14). The Milwaukee Art Museum possesses a similar drawing of a single hand by this artist, suggesting that the study of hands comprised a more extensive series, perhaps intended for a pattern book. Such a book would instruct the young artist not only about the subtleties of light and shade in the delineation of hands, but also about the proper way to hold an important drafting tool, the calipers. Still other drawings were used as patterns for large-scale architectural projects. Giuseppe Galli Bibbiena's elaborate drawing of a baldacchino, with symbols of the Passion, was used as the model for a ceremonial altar for the Paschal service (Pl. 39).

Some drawings are now the only surviving reminders of unrealized projects. Regrettably, Federico Zuccaro's design for a sculpted tomb for Ferdinando de' Medici

(Pl. 59), probably dating from the first decade of the 17th century, was never carried through in marble. The duke's image, flanked by two allegorical figures, is surmounted by the Medici emblem, five pawnbroker's balls, an appropriate symbolic attribute. Indeed, the poet of the marvelous, Giambattista Marino, extolled Medici rule with specific reference to this emblem in his *Rime* (1601).

> Beneath your wise and placid yoke, beneath
> the balls you raise on high gaily, and without
> a sigh, proud Arno bows her willing head.

The cardinal's hat drawn above the balls recalls Ferdinando's service for the Church, an appointment which he received at the age of fourteen, even though he never took holy orders.

Other drawings were doubtless study guides, ways to improve the artist's skill as a draftsman by emulating earlier masters. The *Sibyl* by Giuseppe Cesari, known as the Cavalier d'Arpino, a Roman drawing dated in the 1590s, is one of these (Pl. 44). A careful copy of Raphael's *Sibyl* from the Chigi Chapel, Santa Maria della Pace, Rome, Arpino's drawing betrays a reverence for the master, one that is heightened by his use of black and red chalk, which enhances the drawing's coloristic qualities. Fragonard's spirited drawing of a lusty satyr squeezing grapes betrays his admiration for Rubens (Pl. 18). A painting of this subject now in Dresden, which Fragonard copied, was once attributed to the great Flemish master.

Two fine drawings by anonymous artists also demonstrate the significance of copying for the Old Master draftsman. The *Study after the Portrait of Sir Kenelm Digby* (Pl. 17) is most probably a good 17th-century copy of Robert van der Voerst's engraved portrait of the English scholar and connoisseur, taken from Van Dyck's *Iconography*, a series of engraved portraits of distinguished contemporaries. An enigmatic drawing, identified as *Youth Rejecting Sensual Pleasure* (Pl. 36), can be defini-

tively connected to Pietro Testa's important theoretical etching, *Il liceo della pittura* (*The School of Painting*), dated ca. 1638. The anonymous copyist was doubtless attracted to Testa's sense of classic form. But the artist also may have been sympathetic to the aesthetic ideas concerning the education of the artist expressed in the master's etching. The drawing copies the central part of the etching, which depicts the allegorical passage of the artist from childish imitation to greater intellectual mastery. The ardent youths turning their backs on puerile things are led by the personification of Judgment. These replicas provide clear evidence of how one artist learns from another. They confirm Hoogstraeten's advice that the young artist copy prints and other drawings.

The artist also was required to master the skill of drawing from the live model. The nude male by Ferrau Fenzoni, a late 16th-century North Italian artist, is posed with his left leg raised and his body dramatically twisted—a challenge in foreshortening (Pl. 45). Fenzoni quite possibly adapted this complicated pose for the squirming figures in his painting of the *Last Judgment* in Faenza. Direct observation of the live model, however, extended beyond traditional studio figures. The pen and ink drawing of *Three Gypsies* by the Dutch artist Jacob de Gheyn II (Pl. 12), a draftsman well known for his wide-ranging interests, records a fascination with the curious and exotic which finds a parallel in the literature and art of the period. Gypsies were incorporated into the repertoire of the Commedia dell'Arte, were the fodder for popular songs known as "zingaresche," and even were used as central characters in Cervantes' much translated story *La Gitanilla*. Interest in gypsies also extended to pictorial records of their strange garments. Thus a number of costume books were published illustrating gypsy attire. Among them were *Recueil de la diversité des habits* (1567) by François Desprez, Hans Weigel's *Habitus praecipuorum populorum* (1577), the *Habitus variarum orbis gentium* (1581) of Jean-Jacques Boissard, and Cesare Vecellio's immensely popular *Degli habiti antichi e moderni* (1590).

Of course, the subject of gypsies also attracted De Gheyn's great contemporaries, Caravaggio and Georges de La Tour.

The Old Master draftsman was also charmed by the splendors of landscape. Indeed, landscape was seen as restorative, allowing the artist to escape from his dreary studio. Thus, Van Mander in his *Schilderboeck*, a handbook of practical advice for the artist published in 1604, emphatically stated:

> You young painters who have sat for a long time hunched up, so wrapped up in your incessant work in art that you have become half blind, and have almost deadened and closed your senses....Stop! Lay aside the yoke of your labor....Come let us, soon as the city gate opens, while the time together and enlighten our minds by going to see the beauty outside where beaked musicians sing in the open. There we will look at many views....all of which will help us create a landscape....

Artists readily took this advice, and it was common north and south of the Alps to retreat to the countryside. Even the grave Poussin, whose commitment to the study of noble antiquity is so well known, would take relaxing excursions to Tivoli to make drawings from nature.

The draftsman's attraction to landscape is evident from the drawings exhibited here. Allaert van Everdingen's delicate and meticulous drawing of a river scene depicts the kind of looming, craggy outcropping that could have impressed him during his stay in Sweden and Norway in 1644 (Pl. 11). The Dutch patron, sedentary in the flat polders of Holland, could through this drawing escape to a more remote and strangely singular locale. Following the literary principles of the day, this experience would attest to the breadth of his intelligence. Thus the learned early 17th-century humanist Justus

Lipsius wrote: "Small and narrow minded souls stay at home in their own country:.... In former times and still today, men who have traveled are almost always men of substance." Conversely, a century later, Gainsborough's pastoral landscape, vibrant with white highlights, presents a spontaneous and picturesque view of his beloved English countryside (Pl. 8). Here we find a vivid equivalent to the elegiac poem, "The Deserted Village" (1770), by Gainsborough's contemporary Oliver Goldsmith. "God made the country," Goldsmith maintained, and the rural virtues of "health and plenty" were in abundance.

If the country was regenerative, the city could also have its attraction for the draftsman. The interesting drawing by the Dutch artist Jacob van der Ulft depicts a view of Rome where everyday activities—the cavalcade of horsemen, the lolling idlers—are overshadowed by a monumental triumphal arch (Pl. 16). Like a modern-day picture postcard of a city view, this drawing presents a vision of Rome that is a palpable record of its classical legacy. But it is a view of the Eternal City that conflates once mighty grandeur with the commonplace, perhaps reinforcing the conceit of earthly transience.

Highly finished drawings were particularly prized by collectors and connoisseurs. Tommaso Cavalieri, who received such drawings from Michelangelo, remarked: "The more I look at them, the more they delight me." And Vittoria Colonna praised a Michelangelo drawing of the Crucifixion: "One cannot conceive of an image better made, more living or more finished, and certainly I could never explain how subtly and marvelously it is executed." There are some fine examples of highly finished drawings in the exhibition. A case in point is the drawing of two children by the late 16th-century Italian master Cristoforo Roncalli, perhaps an image of the youthful Christ Child and St. John, inspired by Correggio's angels in San Giovanni Evangelista, Parma (Pl. 56). The carefully executed portrait head by Claude Mellan, an early 17th-century French artist influenced by

Roncalli, demonstrates how a finished drawing can capture a vivid likeness (Pl. 24).

Drawings were also inspired by texts. A fine drawing by Andrea Boscoli is characteristic of the artist's style—pronounced divisions of light and shade, a sinuously mannered foliage, and deeply shaded eyes (Pl. 1). In subject, the drawing can be related to two drawings by Boscoli in the Ashmolean Museum, Oxford, which use Torquato Tasso's monumental epic of strife and passion, *Gerusalemme Liberata (Jerusalem Delivered)*, published in 1581, as a point of departure. An inscription on the back of the Milwaukee drawing identifies the scene as from canto XVI, verse 63, of the poem: "Ed io pur anco l'amo, e in questo lido invendicata ancor piango e m'assido?" ("And do I dare still love him? On this shore, do I still unavenged weep and implore?"). In a cinematic way, the drawing seems to illustrate two phases of the abandonment of the pagan Armida by her lover Rinaldo. On the left, a disconsolate figure sits with hands clasped, a gesture that epitomizes melancholy torpor. In the middle ground a female figure, her hair wildly flying, raises her arms in painful distress. Perhaps this is Armida in a later moment, enraged, grieving, and promising revenge. Tasso portrays her mood in canto XVI, verse 67: "Quivering still with rage and broken sobs, she twists away from the deserted shore, clearly showing her deep madness, her hair disheveled, her eyes sullen, her face flushed." In the background is Armida's circular mountaintop retreat, which Tasso describes in canto XVI, verses 1 and 70.

Drawing, of course, also was a means for thinking creatively and extemporaneously. The exquisite *Holy Family* by the 18th-century Venetian artist Giovanni Battista Tiepolo is an example (Pl. 58). Part of an album devoted to this theme, the drawing is a spontaneous and glittering vision of quivering line.

Many of the drawings presented here are unpublished. I have dealt with a few of them in the preceding pages, and now I would like to single out three from the collection of the Elvehjem Museum that deserve wider recognition. The *Journey to Emmaus* by Pietro Paolo Bonzi, associated with the Carracci school, is entirely characteristic of the artist's drawing style (Pl. 40). The regular hatched lines and the schematic loops to indicate foliage are also found, for example, in Bonzi's drawing of *Diana and Her Nymphs Bathing* (Florence, Uffizi) or *Christ and the Samaritan Woman* (Paris, Louvre). The presentation of the figures in a carefully constructed planar landscape resembles Bonzi's painting of *Tobias and His Companions* in the Doria Pamphilj collection, Rome.

Willem de Poorter's expansive *Adoration of the Magi* also accords with the style of this Rembrandt pupil (Pl. 15). The emphasis on profile form, articulated by the figures of St. Joseph, the Madonna, the kneeling magus, and the attendants, is found in de Poorter's *Circumcision* in Kassel. The wash technique is also characteristic of the artist, as are the facial types. Thus, the aged St. Joseph has an analogue in the astonished onlooker to Christ's left in de Poorter's painting *The Resurrection of Lazarus* in Munich or in the old man who personifies *vanitas* in *The Allegory of Vanity* in Grenoble. The ovoid face of the seated Madonna is similar to types such as the *Esther* in Dublin or the personification of freedom represented in the *Glorification of Freedom* in Copenhagen.

The delicious *Pastoral Concert* by the celebrated Frenchman Nicolas Lancret presents the artist's distinctive traits—attenuated fingers, thick bold strokes in the costumes, and faces with wide eyes and broad cheekbones (Pl. 22). This drawing is lightly squared but does not correspond directly to a surviving painting by Lancret. Lancret, however, did execute drawings that were unconnected to paintings, as in the *Couple Seated on the Ground Looking at a Songbook* in a private collection in New York. The Madison drawing could be merely an independent study by a very prolific draftsman. Indeed, over two thousand drawings were found in Lancret's collection at the time of his death.

Many of the drawings present vexing problems of connoisseurship and iconography. I want to focus particu-

larly upon the drawings in the Milwaukee Art Museum. Some very fine sheets in the collection cannot be attributed to a specific master. The subtle red chalk drawing of the head of a woman, for example, has affinities to the style of Florentine draftsmanship of the late 16th century, although no convincing attribution can be made (Pl. 46). The vigorously drawn study of individual figures for a *Massacre of the Innocents*, an image dominated by complex figure patterns and splotchy shadow, seems to be a Roman work of the late 16th century (Pls. 54, 55). But the name of the artist cannot be fixed.

While these drawings remain problematic, others can be attributed more conclusively. Konrad Oberhuber has plausibly suggested that the charming design for a ceiling painting representing the *Allegory of America*, America denoted by her feathered headdress, is by the 18th-century Austrian artist Bartolomeo Altomonte (Pl. 6). A similar figure, accompanied by personifications of Europe, Africa, and Asia, appears in a more elaborate allegory representing the triumph of the Benedictine order, painted for the monastery of Seitenstetten. Oberhuber also believes that the refined, linear drawing depicting *The Mystic Marriage of St. Catherine of Alexandria* is by the 16th-century Bolognese artist Orazio Samacchini (Pl. 57). This is a reasonable attribution. The drawing is squared, indicating that it served as a preparatory study for a painting. However, as far as I know, no surviving painting by Samacchini corresponds to this image. A beautiful head, drawn in charcoal and heightened with white chalk, was wrongly attributed to Marcantonio Franceschini until Oberhuber plausibly suggested that it was by the 18th-century Bolognese artist Gaetano Gandolfi (Pl. 47). Indeed, the head relates to Gandolfi's Venus in the *Venus Ordering Armor from Vulcan for Aeneas*, dated ca. 1775 and now in Detroit.

Two drawings can be given to 17th-century Genoese masters. *Bacchus and His Attendants*, reveals the characteristic pen and sepia wash technique of Domenico Piola (Pl. 53). The drawing is clearly analogous to such sheets as Piola's *Rape of Europa* in Turin. The corpulent Bacchus is surrounded by attendants. A playful satyr fills his large cup. Two bacchantes gaze fondly at him, and he responds. The curious animal at his feet may be Piola's version of a lynx, the animal Ovid associated with Bacchus (*Metamorphoses*, IV). A copy of Ovid's book was in Piola's library. The image of the dissolute Bacchus—his "wine belly" is prominent—has its antecedent in a Rubens depiction of the sodden Bacchus in the Palazzo Pallavicino in Genoa.

The *Hercules and Antaeus*, at one time implausibly attributed to Parmigianino, may be by Gregorio de Ferrari, Piola's son-in-law, active in Genoa in the late 17th century (Pl. 3). The drawing may have been a study for a painting of the same theme in the Palazzo Cattaneo Adorno. Hercules, emblematic of virtue, provided an *exemplum virtutis* for the patron. The strangely effeminate Antaeus, a Libyan giant who saved the skulls of his victims, is indebted to Correggio's Magdalene in the *Giorno*, a painting in Parma which Ferrari knew intimately from his prolonged sojourn there. There are also affinities to Piola's physiognomic types, such as that in the *Vanitas* in a private collection. Piola's influence on Gregorio would have been natural: not only were the two artists related, but they also shared commissions.

A drawing representing *Dancing Nymphs* has confounded scholars (Pl. 21). Its pastoral classical subject matter suggests a French artist, and previous attributions oscillate between Poussin and the facilely imitative Sébastien Bourdon. But on the basis of the drawing's cursory draftsmanship, characterized by a nervous staccato line, the free use of wash, and the scalloped treatment of the foliage, it is likely that this charming piece is by the late 17th-century Frenchman Raymond La Fage. A prolific draftsman, La Fage produced several hundred drawings. The Milwaukee sheet can be related to his *Bacchanal* in Stockholm or the *Love Summoned to Parnassus* in the British Museum.

A delicate red chalk drawing of a youth holding a

spear in a landscape presents iconographic and stylistic problems (Pl. 43). The work is plausibly ascribed to the Bolognese master Simone Cantarini in the Milwaukee Art Museum's accession files. The pointed, elongated fingers of the youth, his triangular eyes, surmounted by a stroke for the eyebrows, the use of parallel hatched lines, and the active rhythm on the tree trunk, resembling the pulsing of a cardiogram, are all characteristics of this prolific artist. Identification of the figures, however, is less secure. The foreground figure has been interpreted as Diana, goddess of the hunt, or St. John with a staff. But none of the traditional attributes of these figures is present. Perhaps the beautiful, androgynous youth with a hunting spear is Adonis. The two women, lightly sketched in the background, may be Venus and Persephone, the goddesses who were attracted to Adonis' beauty.

A particularly thorny iconographic problem is presented by a cursory drawing attributed to the 18th-century French artist Pierre Subleyras (Pl. 28). In the center of the composition, a reclining, semi-clad figure holds a cup in his hand. He looks up at a figure standing by his side. The pile of armor near the bed suggests that this is a scene with a military reference. Indeed, this enigmatic image depicts a story from the life of the glorious military hero Alexander the Great. Alexander, after drinking medicine prepared by his physician Philippus, confronts the latter with a slanderous letter claiming that the doctor has been corrupted by Alexander's enemy, the Persian king. The doctor declares his innocence. The drawing seems to be a variant of Giovanni Lanfranco's painting of this story, dated ca. 1609 and once in the villa of Cardinal Montalto in Rome. Since Subleyras was in Rome from 1728 on, he could have seen the painting or one of the copies made after it.

The meaning of the star resting upon the head of the winged figure of Time in Johann Andreas Wolff's drawing, *Allegory of Time as Death*, probably dating from the early 18th century, is far easier to decipher (Pl. 35). Cesare Ripa's venerable iconographic handbook, the *Iconologia*, connects the stars to Time since "the stars control all things subject to time."

Among the most curious works on exhibition are the four drawings by the 18th-century scientist and theoretician Jacob Leupold (Pls. 30-33). They are widely disparate in subject, ranging from the comically grotesque figure of a bloated, gap-toothed woman to the poignant depiction of the sore-ridden Lazarus licked by a dog. A member of the Berlin Academy, Leupold's special interest was in anamorphic distortion—imagery that could only be seen correctly with the use of a cylindrical mirror. In Leupold's depiction of a skull, impossibly elongated when seen without this visual aid, we not only find a powerfully rendered image, but also a trenchantly learned one. Indeed, there was a long tradition which held that the mirror was something magically connected to the nether-world. The humanist Cornelius Agrippa noted that the mirror could raise ghosts, and the power of the mirror to conjure the "souls of the dead" was also remarked upon by the Renaissance mathematician Jean Pena. In this drawing, the theme of the ephemeral nature of man's existence is once again powerfully represented.

Leupold's drawings, and the others on exhibition, confirm what the Count de Caylus wrote over two hundred years ago about the significance of drawings: "Nothing so excites the genius....as the examination of a fine drawing....In drawings one sees exposed and without any deception the manner in which the painter has known how to read nature and the manner in which he has sometimes known how to take a pleasing liberty with it."

PLATES

All the drawings in the exhibition are reproduced in the catalogue.
The first three plates are incorporated within the text; Pl. 4 leads off this section.
The drawings here are grouped alphabetically by country, then alphabetically by the artist's name.
Each drawing in the collection of the Milwaukee Art Museum has been examined and recatalogued.
Information for works from other collections has been supplied by the lenders.
Dimensions are for sheet size, taken at the widest points on irregular pages; height precedes width.

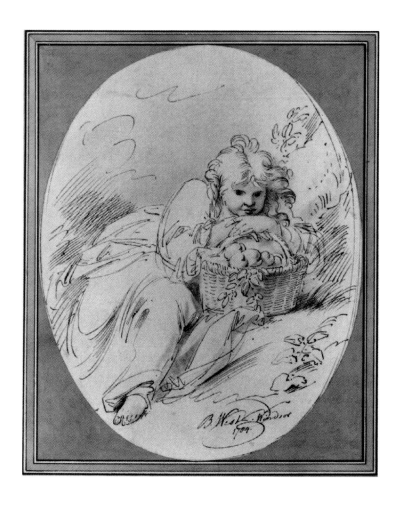

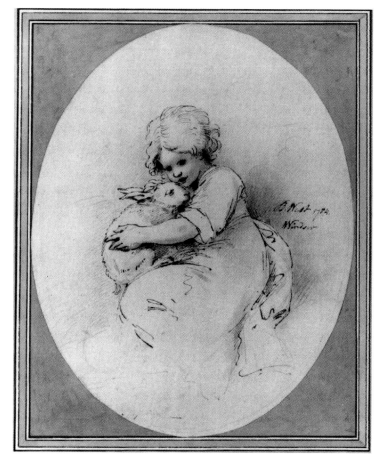

4. **Benjamin West** (American, 1738-1820)
Young Girl with Basket of Fruit, 1784
Pen and brown and black ink with red, blue, and black pastel, on cream laid paper
6 7/8 x 5 7/16 in. (17.5 x 13.8 cm) oval
Milwaukee Art Museum; gift of Richard and Erna Flagg M1961.91

5. **Benjamin West** (American, 1738-1820)
Young Girl with Rabbit, 1784
Pen and brown ink with red, blue, and black pastel over graphite, on cream laid paper
6 5/8 x 5 5/16 in. (16.8 x 13.5 cm) oval
Milwaukee Art Museum; gift of Richard and Erna Flagg M1961.92

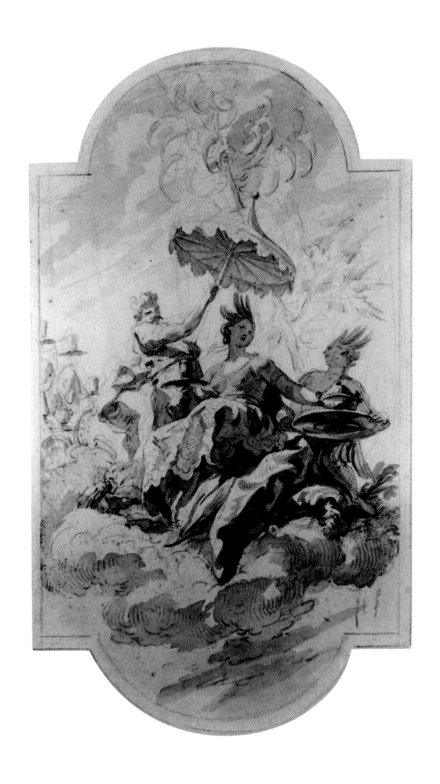

6. **Bartolomeo Altomonte** (Austrian, 1702-1779)
Allegory of America
Gray wash over graphite, on cream laid paper
10 3/8 x 6 in. (26.4 x 15.2 cm)
Milwaukee Art Museum; Max E. Friedmann—Elinore Weinhold Friedmann Bequest M1954.37

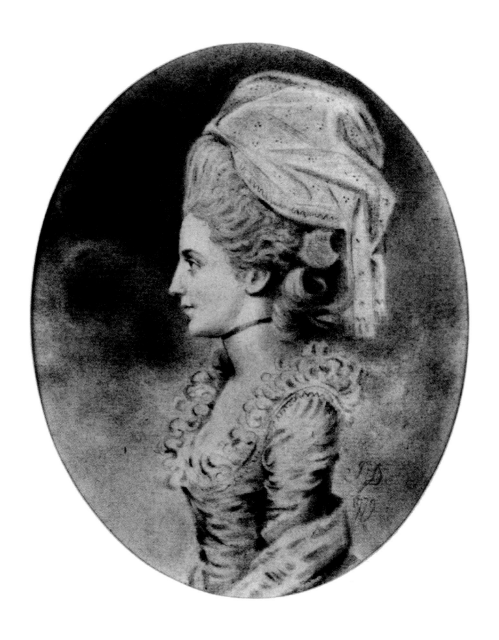

7. **John Downman** (British, 1750-1824)
The Honorable Mrs. Arbuthnot, 1779
Chalk with watercolor wash, on cream laid paper
7 1/2 x 5 7/8 in. (19 x 14.9 cm) oval
Milwaukee Art Museum; Catherine Jean Quirk Bequest M1989.60

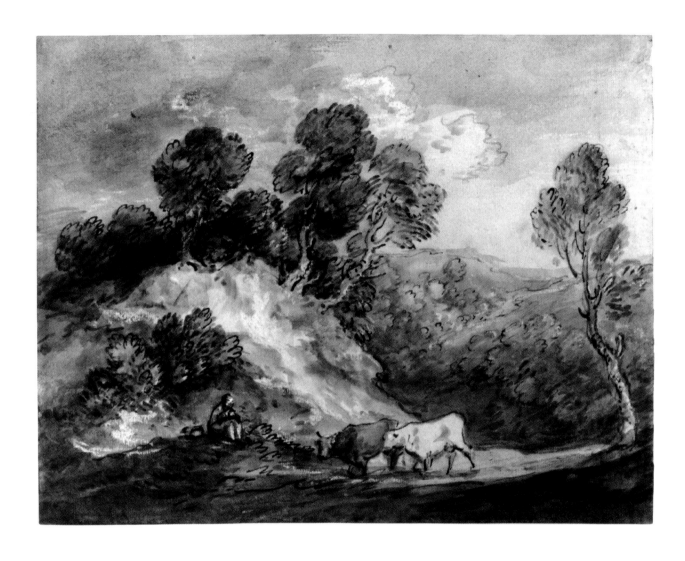

8. **Thomas Gainsborough** (British, 1727-1788)
Landscape with Cattle
Pen and black ink with black and gray wash and white heightening, on cream laid paper
11 1/16 x 14 3/8 in. (28.1 x 36.5 cm)
Milwaukee Art Museum; gift of the family, in memory of Isabelle Miller M1985.79

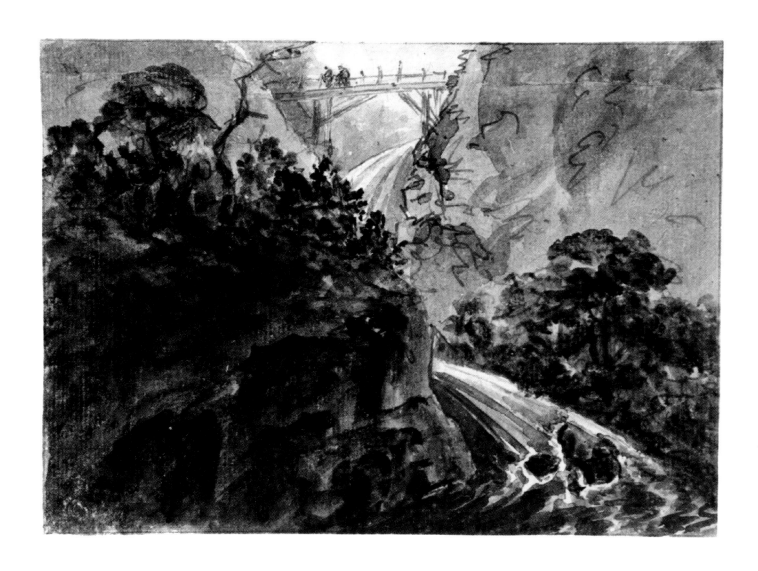

9. **William Gilpin** (British, 1724-1804)
Landscape, ca. 1789-94
Wash and reed pen and India ink, on paper
6 5/8 x 9 5/8 in. (16.8 x 24.4 cm)
Elvehjem Museum of Art, University of Wisconsin—Madison; Anonymous Fund and Humanistic Fund purchase 69.14.1

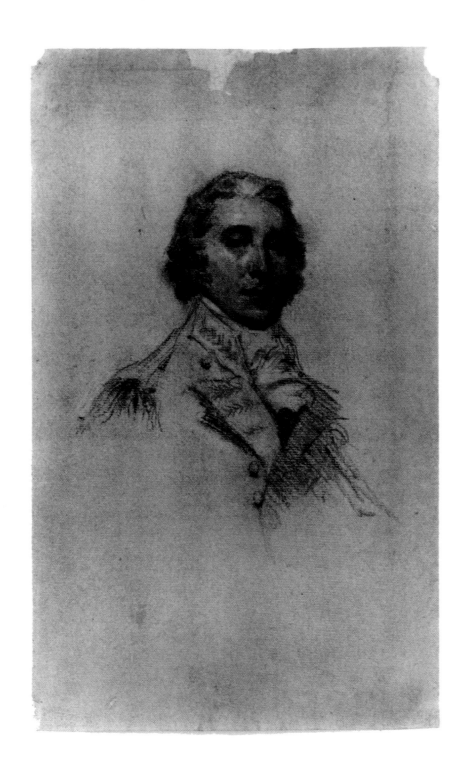

10. Attributed to **Henry Raeburn** (British, 1756-1823)
Portrait of an Officer
Brown crayon, with reddish-brown toned ground, on cream laid paper
11 1/4 x 7 in. (28.7 x 17.8 cm)
Milwaukee Art Museum; gift of Mr. and Mrs. R.V. Krikorian M1980.209

11. **Allaert van Everdingen** (Dutch, 1621-1675)
Landscape with Travelers
Brown and black wash, on paper
5 1/4 x 7 in. (13.3 x 17.8 cm)
Collection of Esther Leah Ritz

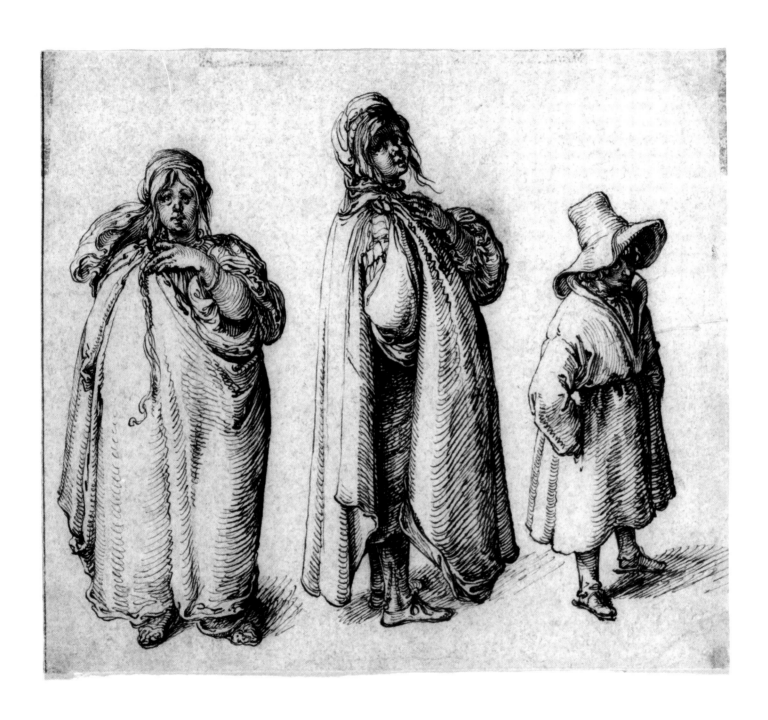

12. **Jacob de Gheyn II** (Dutch, 1565-1629)
Three Gypsies, ca. 1605
Pen and iron gall ink, on tan laid paper
8 15/16 x 10 1/4 in. (22.7 x 26 cm)
The Art Institute of Chicago; Margaret Day Blake Collection 1959.2

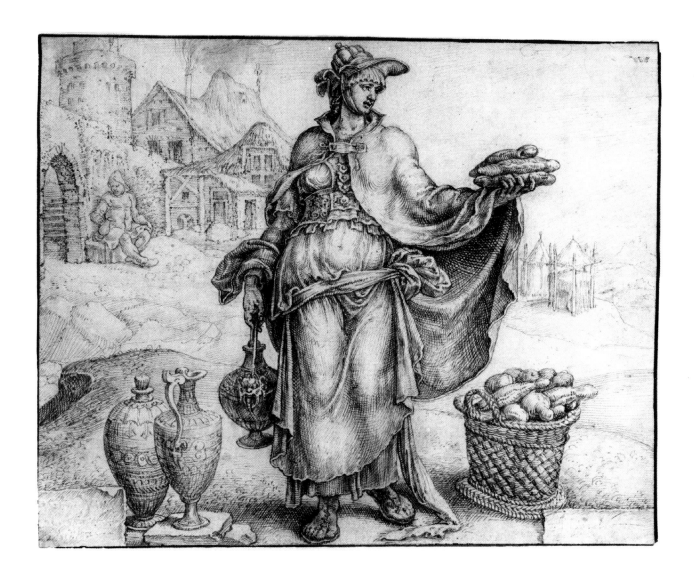

13. **Maerten van Heemskerck** (Dutch, 1498-1574)
Abigail, ca. 1560
Pen and brown ink, incised with stylus, on ivory laid paper
7 7/8 x 9 7/8 in. (20 x 25.1 cm)
The Art Institute of Chicago; Simeon B. Williams Fund 1961.33

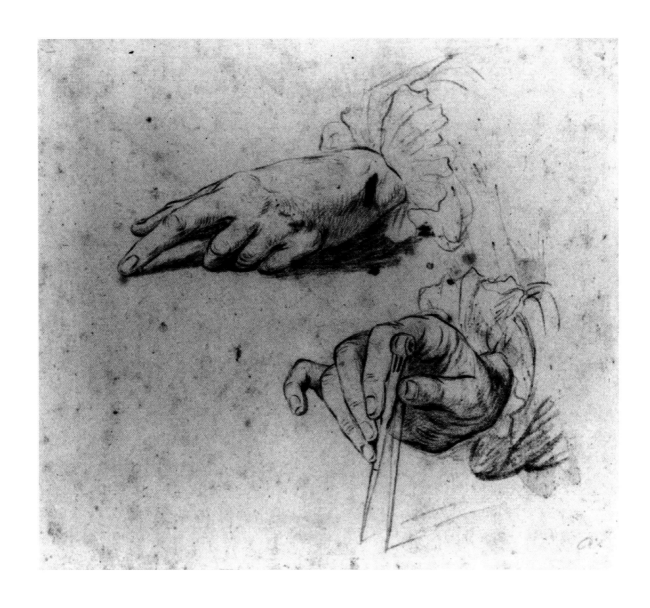

14. **Jan Josef Horemans the Elder** (Dutch, 1682-1759)
Study of Two Hands
Red chalk, on cream laid paper
6 1/2 x 7 5/16 in. (16.5 x 18.6 cm)
Milwaukee Art Museum; Max E. Friedmann—Elinore Weinhold Friedmann Bequest M1954.64

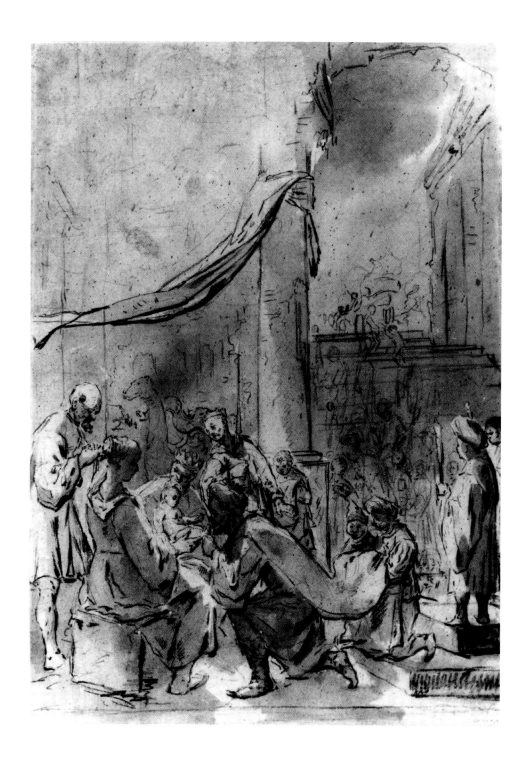

15. **Willem de Poorter** (Dutch, 1608-ca. 1650)
Adoration of the Magi
Black chalk and black carbon wash, on paper
11 7/16 x 8 1/4 in. (29.1 x 21 cm)
Elvehjem Museum of Art, University of Wisconsin—Madison; University Fund purchase 66.6.4

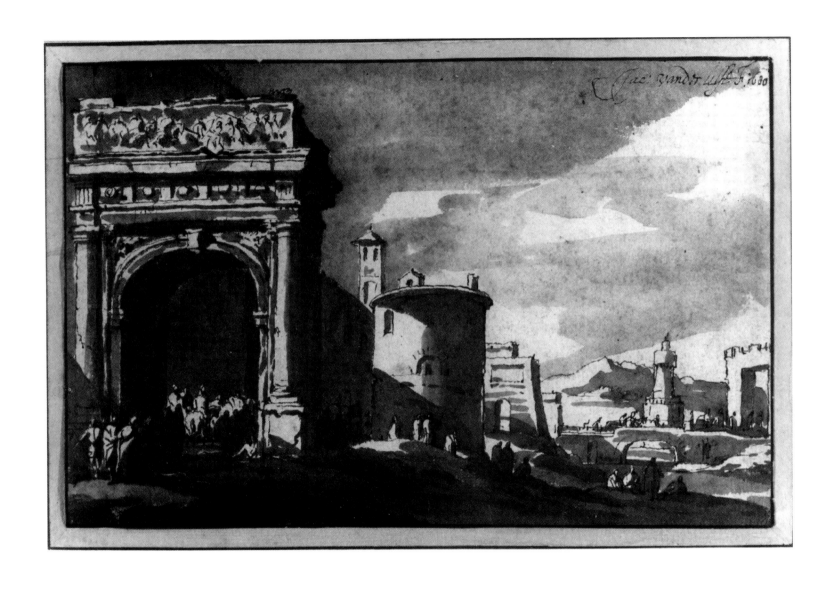

16. **Jacob van der Ulft** (Dutch, 1627-1689)
Roman Landscape, 1680
Quill pen and iron gall ink and wash, on paper
3 15/16 x 6 1/4 in. (10 x 15.9 cm)
Elvehjem Museum of Art, University of Wisconsin—Madison; University Fund purchase 66.3.1

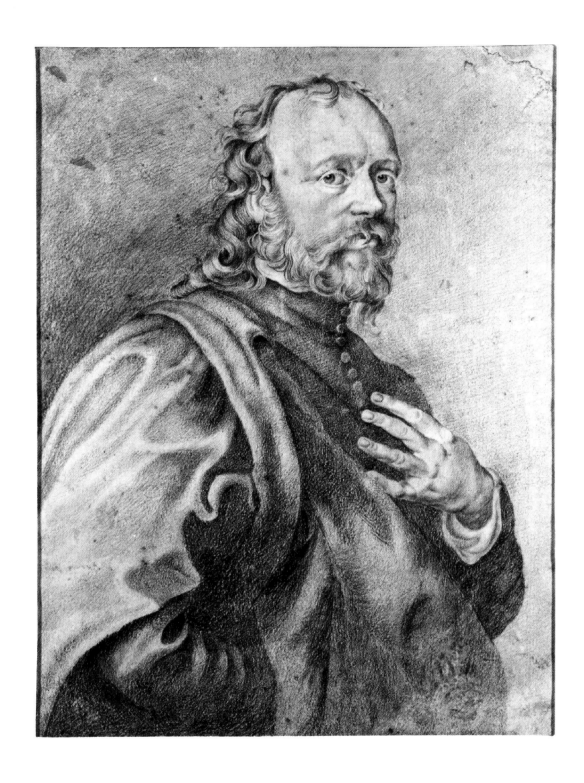

17. **Anonymous,** after **Antony Van Dyck** (Flemish, 1599-1641)
Study after the Portrait of Sir Kenelm Digby
Crayon and graphite, on paper
8 3/4 x 6 7/8 in. (22.2 x 17.4 cm)
The Patrick and Beatrice Haggerty Museum of Art, Marquette University, Milwaukee; gift of Philip Pinsof 76.31

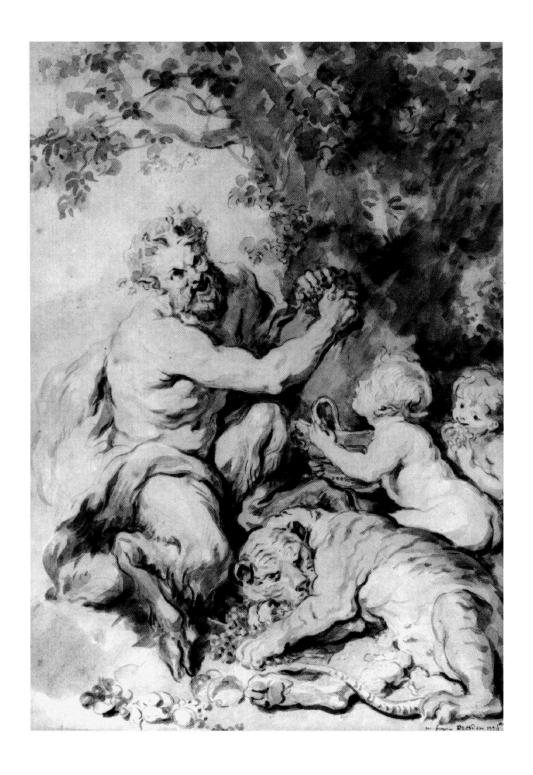

18. **Jean-Honoré Fragonard** (French, 1732-1806)
Satyr Pressing Grapes Beside a Tiger, 1774
Brush and brown ink and brown wash heightened with traces of white gouache over graphite, on tan paper
13 5/8 x 9 11/16 in. (34.6 x 24.6 cm)
The Art Institute of Chicago; gift of Mr. and Mrs. Robert J. Hamman in honor of Suzanne Folds McCullagh 1982.500

19. French, 18th century
Portrait of a Young Woman, ca. 1750-70
Charcoal and red crayon, with white heightening, on paper
7 x 6 in. (17.8 x 15.2 cm)
Collection of Jeff Soref

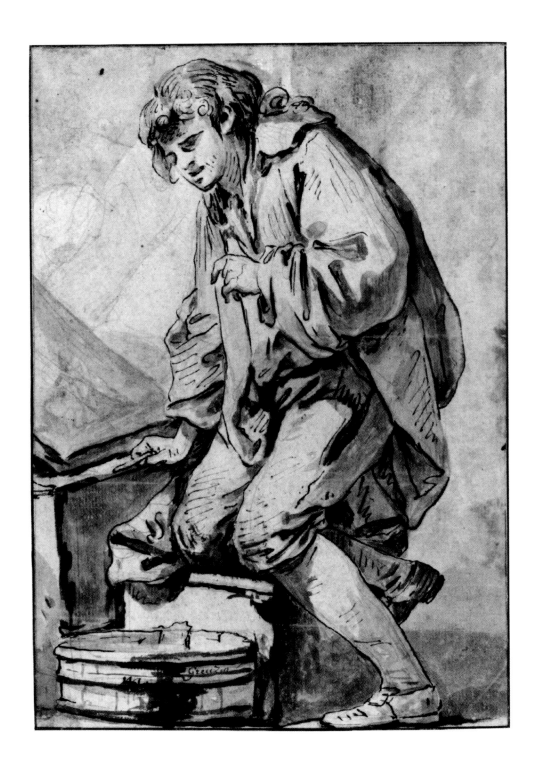

20. **Jean-Baptiste Greuze** (French, 1725-1805)
Young Artist at Drawing Board, ca. 1756-57
Pen and brown ink and wash, on paper
9 1/8 x 6 1/2 in. (23.2 x 16.5 cm)
Elvehjem Museum of Art, University of Wisconsin—Madison; Class of 1943 Gift Fund purchase 1973.139

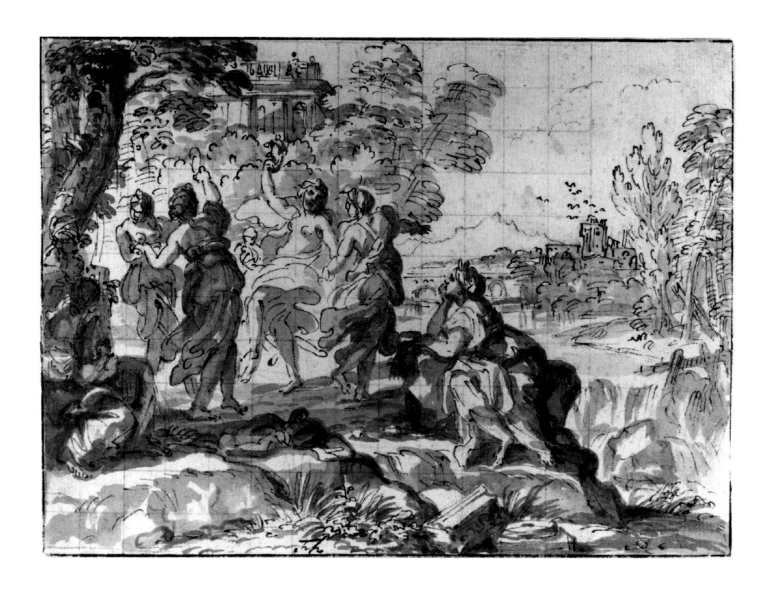

21. Attributed to **Raymond La Fage** (French, 1650-1684)
Dancing Nymphs
Pen and brown ink with brown wash over red chalk, squared in graphite, on cream laid paper
6 x 8 3/16 in. (15.2 x 20.8 cm)
Milwaukee Art Museum; Max E. Friedmann—Elinore Weinhold Friedmann Bequest M1954.49

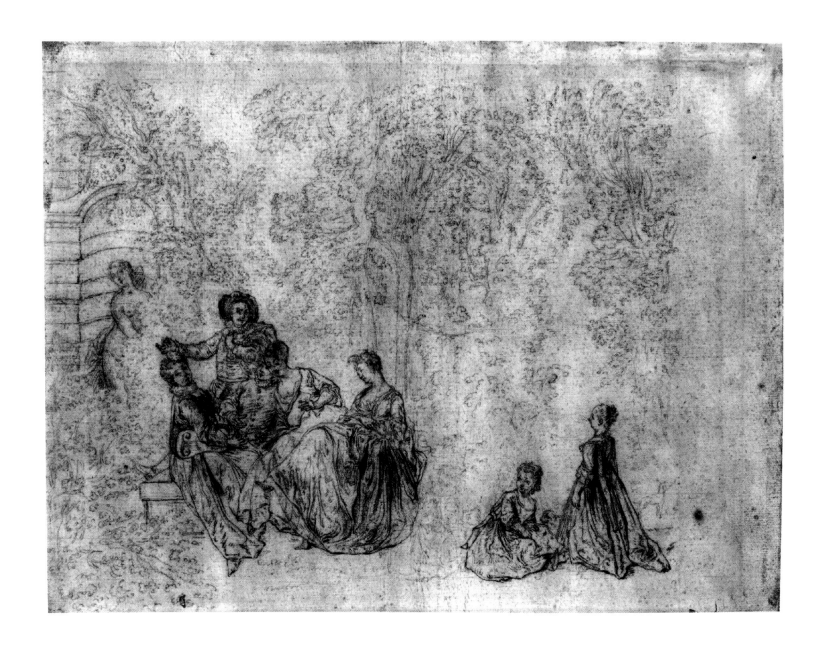

22. **Nicolas Lancret** (French, 1690-1745)
The Pastoral Concert, by 1734
Red chalk, on paper
10 1/2 x 14 7/16 in. (26.7 x 36.7 cm)
Elvehjem Museum of Art, University of Wisconsin—Madison; Professor Joseph Tucker Memorial Fund purchase 64.1.5

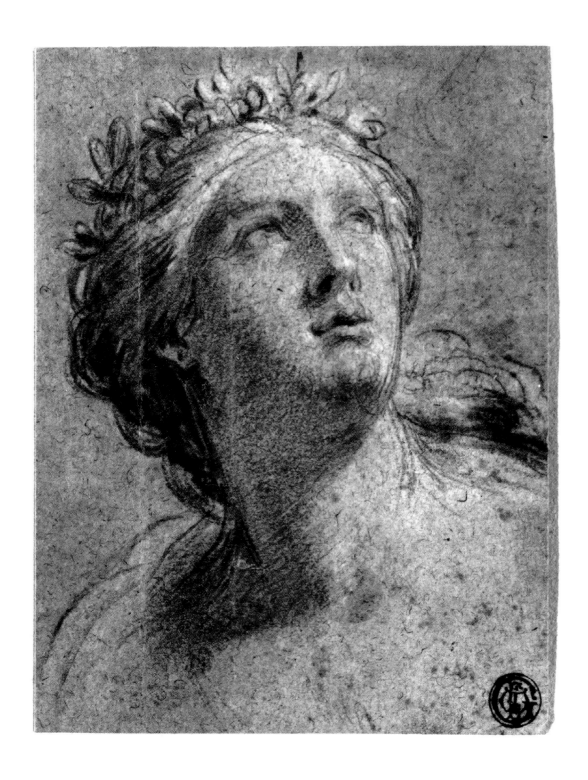

23. **Eustache Le Sueur** (French, 1617-1655)
Head of a Woman, 1646-49
Black chalk, on buff laid paper
5 3/16 x 4 in. (13.2 x 10.2 cm)
The Art Institute of Chicago; Leonora Hall Gurley Memorial Collection 1922.227

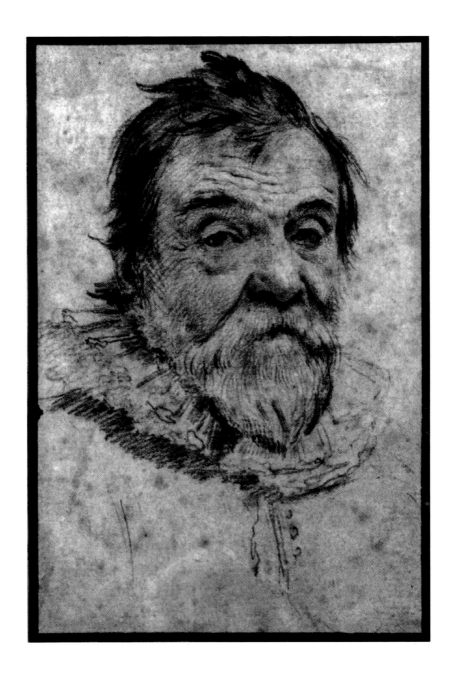

24. **Claude Mellan** (French, 1598-1688)
Portrait of a Bearded Man
Black and red chalk, on buff paper
5 1/16 x 3 7/16 in. (12.9 x 8.7 cm)
The Art Institute of Chicago; gift of Mr. and Mrs. Everell D. Graff 1958.556

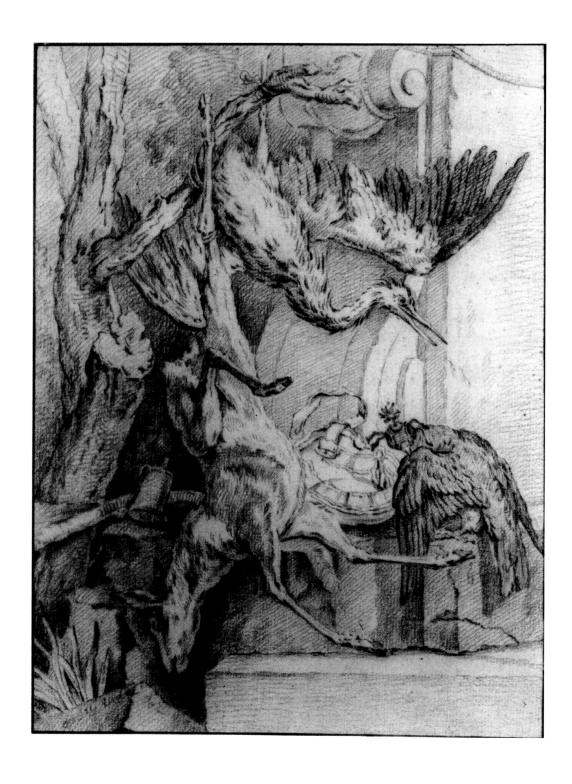

25. **Jean-Baptiste Oudry** (French, 1686-1755)
Roe and Heron Suspended from a Tree Branch, ca. 1721
Red chalk, on paper
10 7/8 x 8 1/8 in. (27.6 x 22.7 cm)
Elvehjem Museum of Art, University of Wisconsin—Madison; Class of 1947 Gift Fund purchase 1973.140

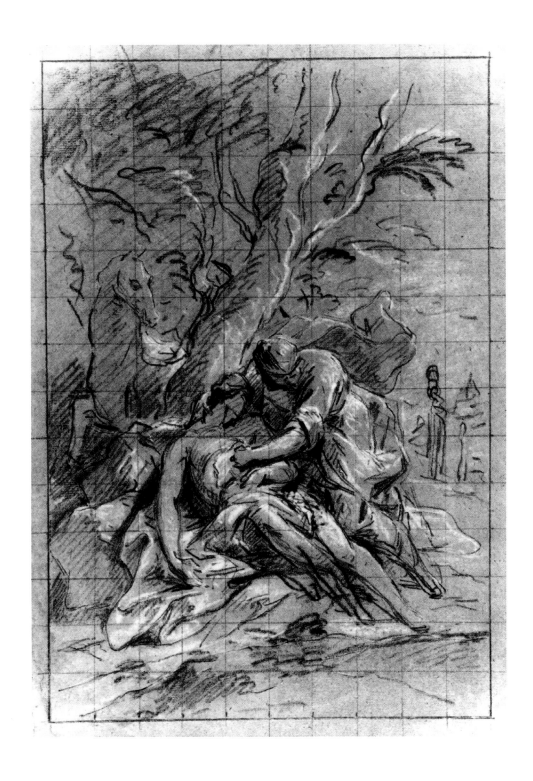

26. **Jean Restout the Younger** (French, 1692-1768)
The Good Samaritan
Black chalk heightened with white chalk, on brown paper
17 1/4 x 10 1/2 in. (43.8 x 26.7 cm)
Elvehjem Museum of Art, University of Wisconsin—Madison; University Fund purchase 66.2.2

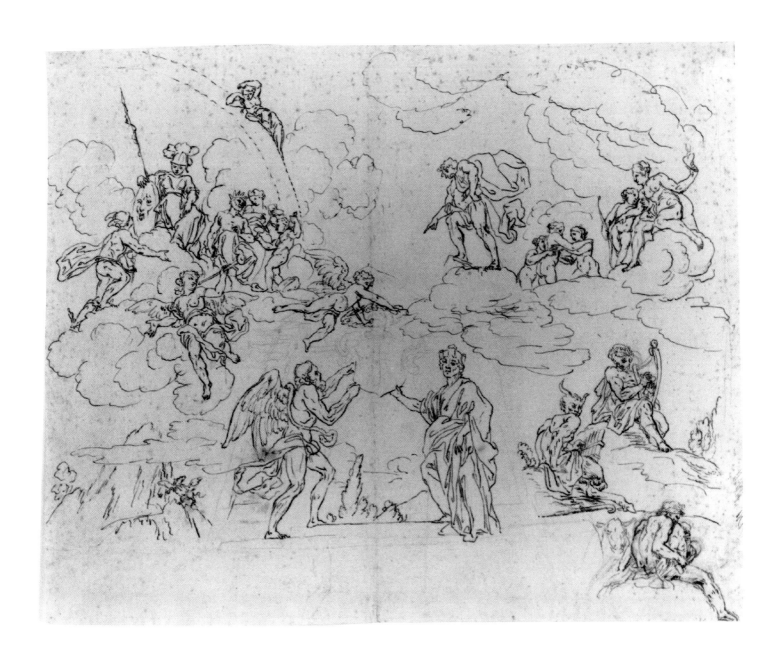

27. **Antoine Rivaltz** (French, 1667-1735)
Allegorical Scene, ca. 1700
Pen and brown ink over graphite, on cream laid paper
11 7/16 x 14 1/4 in. (29.1 x 36.2 cm)
Milwaukee Art Museum; Max E. Friedmann—Elinore Weinhold Friedmann Bequest M1954.35

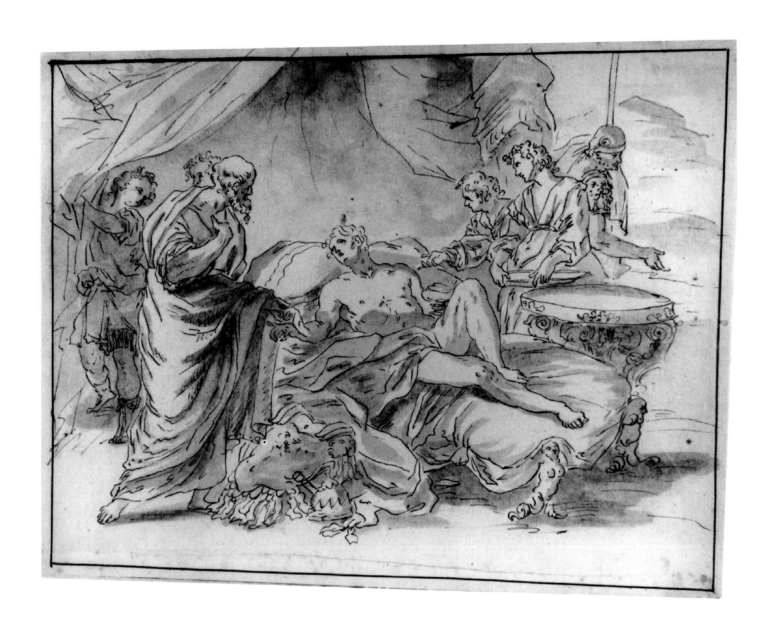

28. Attributed to **Pierre Hubert Subleyras** (French, 1699-1749)
Alexander the Great Confronting His Physician
Pen and brown ink with brown wash over graphite, on cream laid paper
8 11/16 x 11 3/16 in. (22.1 x 28.4 cm)
Milwaukee Art Museum; Max E. Friedmann—Elinore Weinhold Friedmann Bequest M1954.43

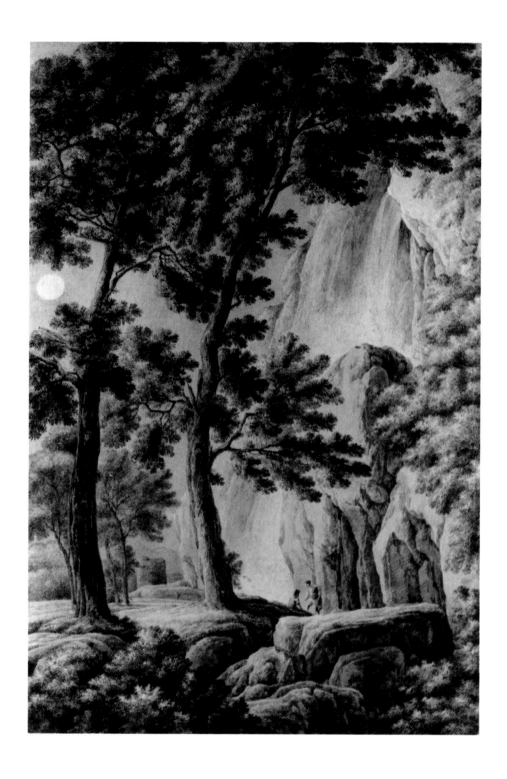

29. **Franz Innocenz Josef Kobell** (German, 1749-1822)
Nocturnal Landscape with Two Figures, ca. 1800
Brown wash, on cream wove paper
13 9/16 x 9 3/16 in. (34.4 x 23.3 cm)
Milwaukee Art Museum; purchase, René von Schleinitz Memorial Fund M1990.57

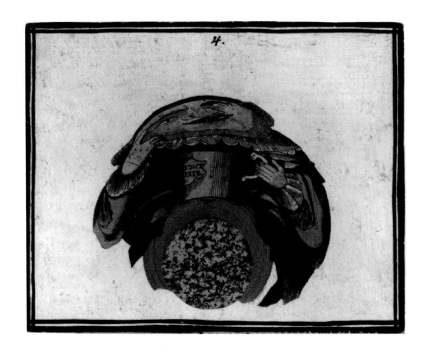

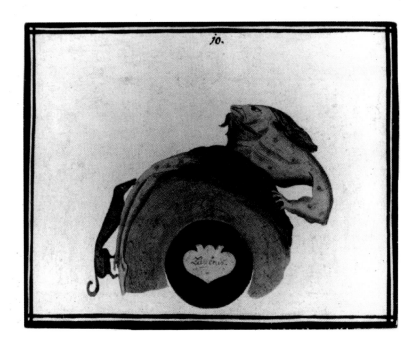

30. **Jacob Leupold** (German, 1674-1729)
Man Drinking, plate 4, from *Mechanicai lipsiensis anamorphosis cylindrica et
conica curiosa* or *Neu inventirte Figuren zu denen Cylinder und Conischen Spieeln
zufinden nebst denen Spiegeln bey dem Autore*, ca. 1700-25
Gouache and ink with collage, on cardboard
11 1/4 x 14 1/4 in. (28.6 x 36.2 cm)
Milwaukee Art Museum; purchase M1969.69g

31. **Jacob Leupold** (German, 1674-1729)
Lazarus, plate 10, from *Mechanicai lipsiensis anamorphosis cylindrica et
conica curiosa* or *Neu inventirte Figuren zu denen Cylinder und Conischen Spieeln
zufinden nebst denen Spiegeln bey dem Autore*, ca. 1700-25
Gouache and ink with collage, on cardboard
11 1/4 x 14 5/16 in. (28.6 x 36.4 cm)
Milwaukee Art Museum; purchase M1969.69e

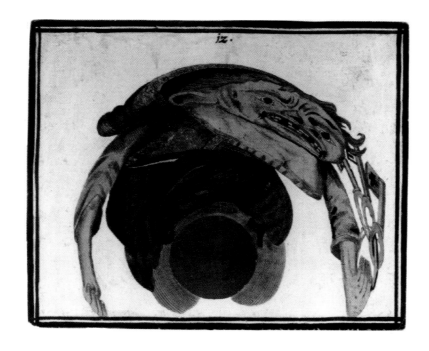

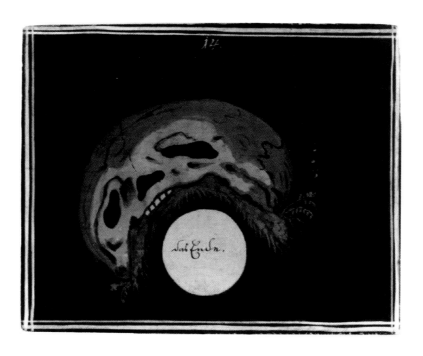

32. **Jacob Leupold** (German, 1674-1729)
Woman with Keys, plate 12, from *Mechanicai lipsiensis anamorphosis cylindrica et conica curiosa* or *Neu inventirte Figuren zu denen Cylinder und Conischen Spieeln zufinden nebst denen Spiegeln bey dem Autore*, ca. 1700-25
Gouache and ink with collage, on cardboard
11 1/4 x 14 1/4 in. (28.6 x 36.2 cm)
Milwaukee Art Museum; purchase M1969.69h

33. **Jacob Leupold** (German, 1674-1729)
Skull, plate 14, from *Mechanicai lipsiensis anamorphosis cylindrica et conica curiosa* or *Neu inventirte Figuren zu denen Cylinder und Conischen Spieeln zufinden nebst denen Spiegeln bey dem Autore*, ca. 1700-25
Gouache and ink with collage, on cardboard
11 1/4 x 14 3/8 in. (28.6 x 36.5 cm)
Milwaukee Art Museum; purchase M1969.69f

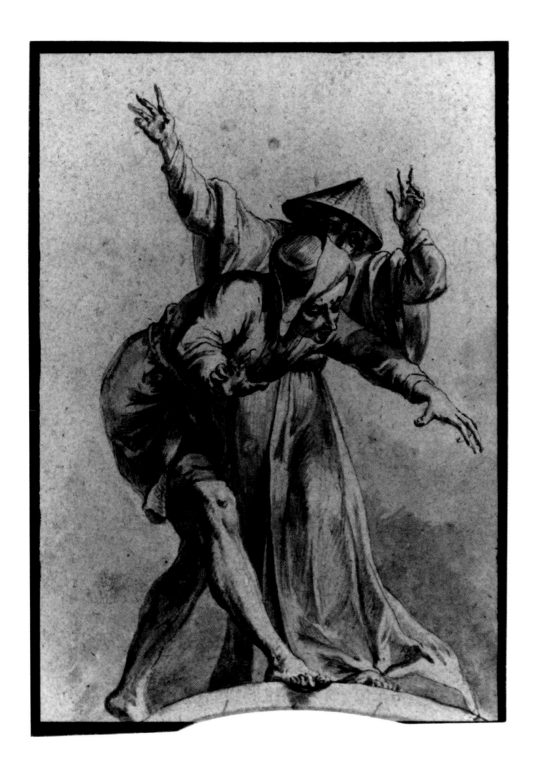

34. Johann Esaias Nilson (German, 1721-1788)
Figures of the Italian Comedy
Pen and black ink with gray wash and white heightening, traced in graphite, on blue thread paper
5 3/16 x 3 11/16 in. (13.2 x 9.4 cm)
Milwaukee Art Museum; Max E. Friedmann—Elinore Weinhold Friedmann Bequest M1954.12

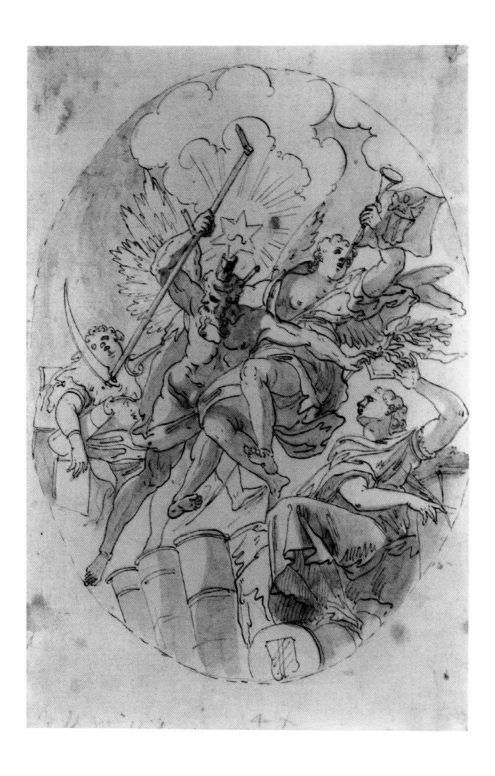

35. **Johann Andreas Wolff** (German, 1652-1716)
Allegory of Time as Death, late 17th century
Pen and black ink with gray wash over graphite, on cream laid paper
11 5/8 x 7 13/16 in. (29.5 x 19.8 cm)
Milwaukee Art Museum; Max E. Friedmann—Elinore Weinhold Friedmann Bequest M1954.46

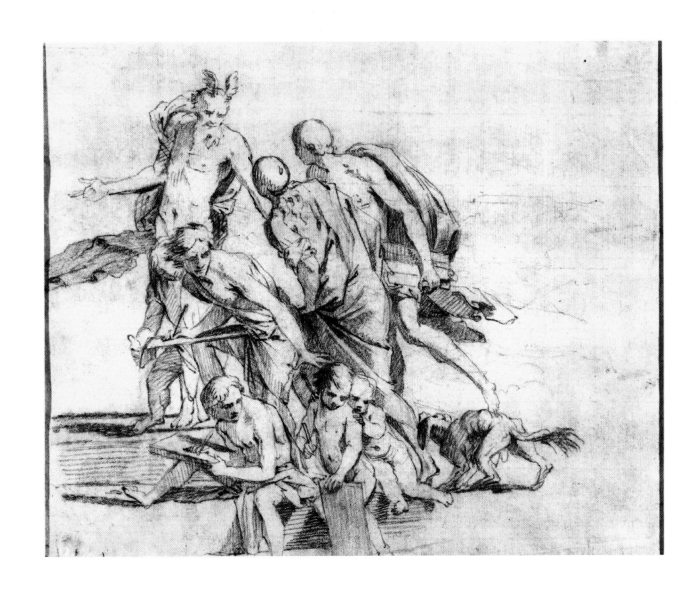

36. **Anonymous,** after **Pietro Testa** (Italian, 1611-1650)
Youth Rejecting Sensual Pleasure (recto), copy from Testa's *Il Liceo della Pittura*
Red chalk, on paper
7 x 9 1/2 in. (17.8 x 24.1 cm)
Collection of Esther Leah Ritz

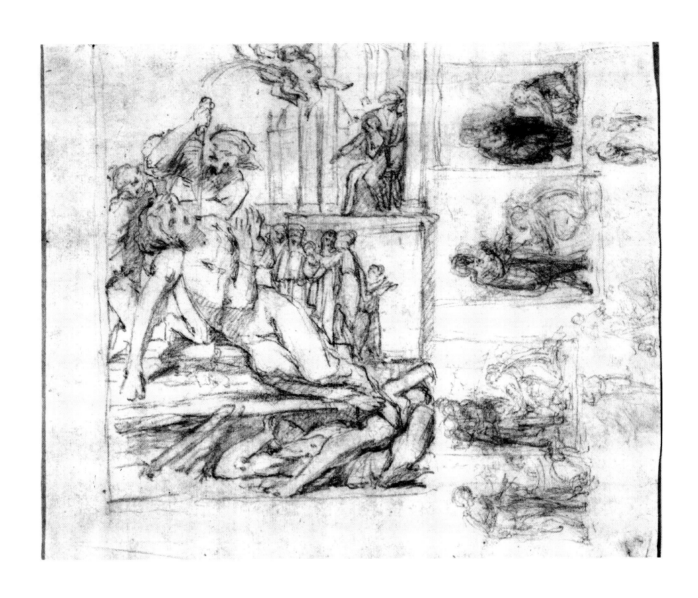

37. **Anonymous,** after **Pietro Testa** (Italian, 1611-1650)
Composition for the Martyrdom of St. Justina, et al. (verso)
Red chalk, on paper
7 x 9 1/2 in. (17.8 x 24.1 cm)
Collection of Esther Leah Ritz

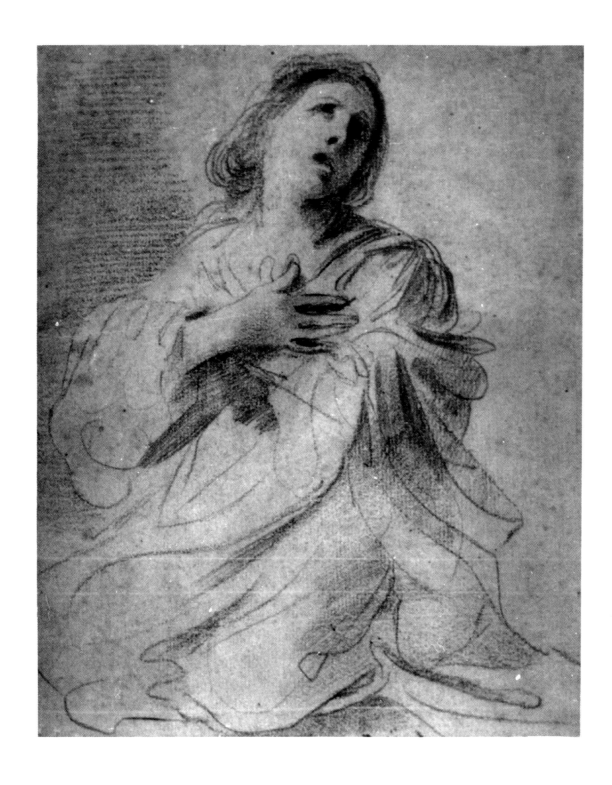

38. Giovanni Francesco Barbieri, called **Il Guercino** (Italian, 1591-1666)
St. Mary Magdalen
Red chalk, on paper
8 1/2 x 6 3/4 in. (21.6 x 17.1 cm)
Elvehjem Museum of Art, University of Wisconsin—Madison; Oskar Hagen Memorial Fund purchase 63.7.1

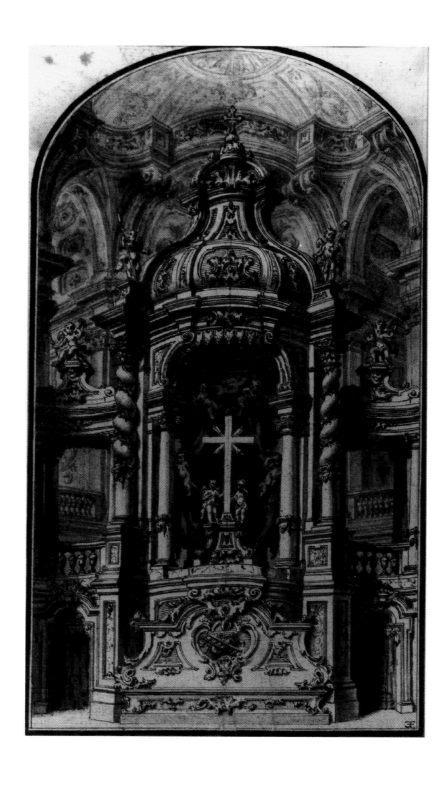

39. **Giuseppe Galli Bibbiena** (Italian, ca. 1696-1756)
A Project for the Decoration of a High Altar
Pen and brown ink with gray wash and blue-gray and rose watercolor, on paper
17 1/16 x 10 1/8 in. (43.3 x 25.7 cm)
Elvehjem Museum of Art, University of Wisconsin—Madison; University Fund purchase 66.2.1

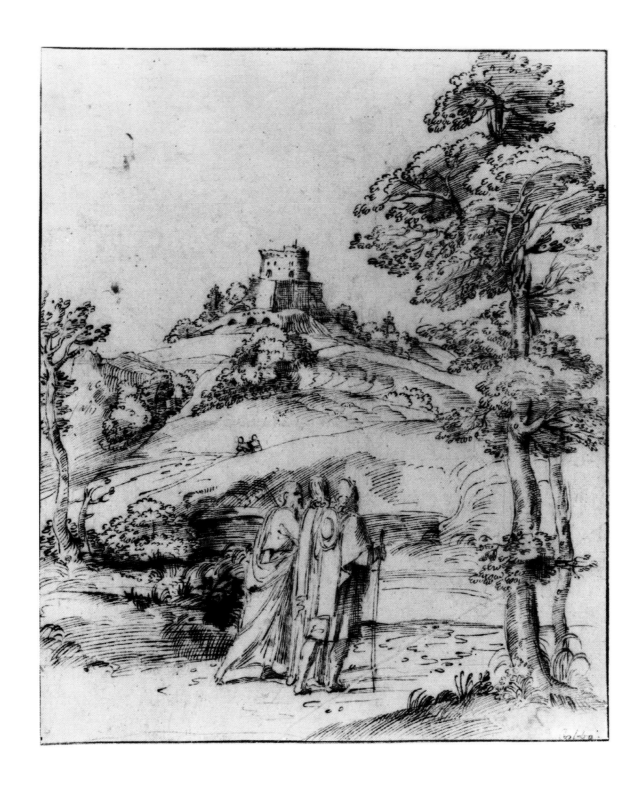

40. **Pietro Paulo Bonzi,** called **Il Gobbo** (Italian, ca. 1580-1640)
Journey to Emmaus
Quill pen and bistre, on paper
12 7/8 x 10 3/4 in. (32.7 x 27.3 cm)
Elvehjem Museum of Art, University of Wisconsin—Madison; gift of Miss Charlotte C. Gregory 64.15.2

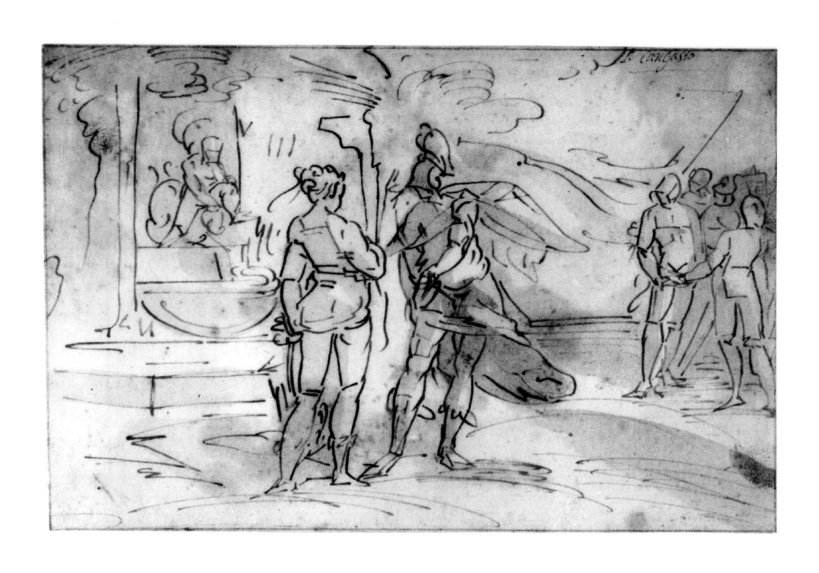

41. **Luca Cambiaso** (Italian, 1527-1585)
Meeting of Numa Pompilius with the Nymph Egeria at the Holy Well
Sepia ink and wash, on paper
7 5/8 x 11 7/8 in. (19.4 x 30.2 cm)
Collection of Esther Leah Ritz

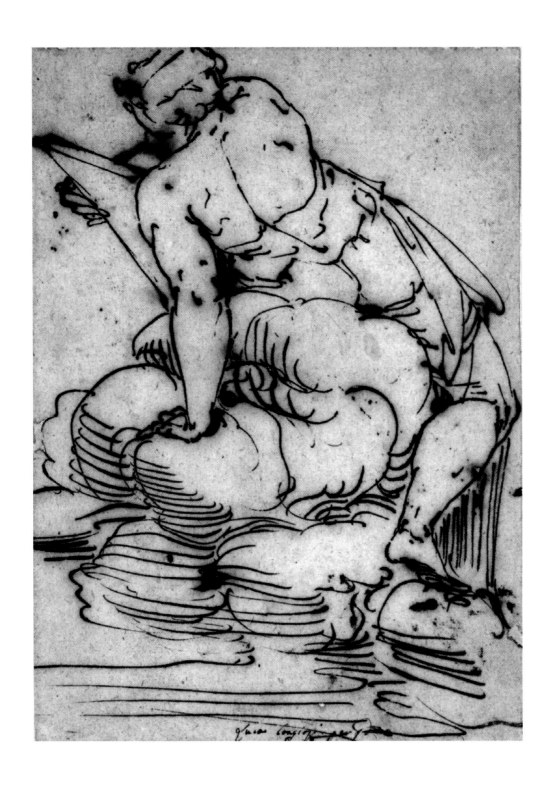

42. **Luca Cambiaso** (Italian, 1527-1585)
Prophet
Pen and ink, on paper
12 1/8 x 8 7/8 in. (30.8 x 22.5 cm)
Collection of Esther Leah Ritz

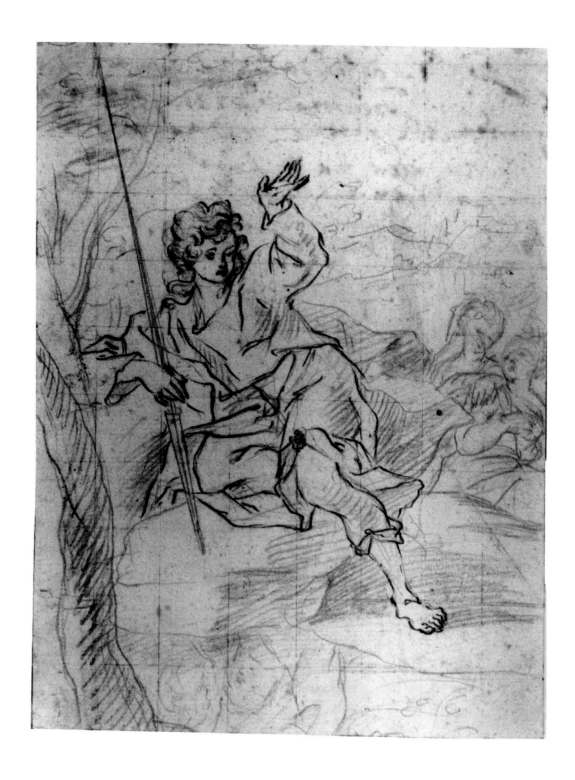

43. Attributed to **Simone Cantarini** (Italian, 1612-1648)
Adonis (?)
Pen and black ink over red chalk, squared for transfer, on buff laid paper
9 7/16 x 7 3/16 in. (24 x 18.3 cm)
Milwaukee Art Museum; Max E. Friedmann—Elinore Weinhold Friedmann Bequest M1954.44

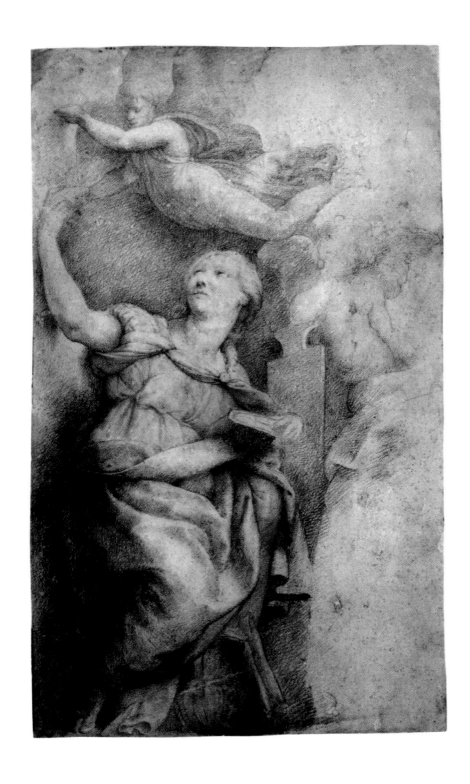

44. Giuseppe Cesari, called **Il Cavalier d'Arpino** (Italian, 1568-1640)
Sibyl, 1590s
Black and red chalk, on paper
14 3/4 x 9 in. (37.5 x 22.9 cm)
Private collection

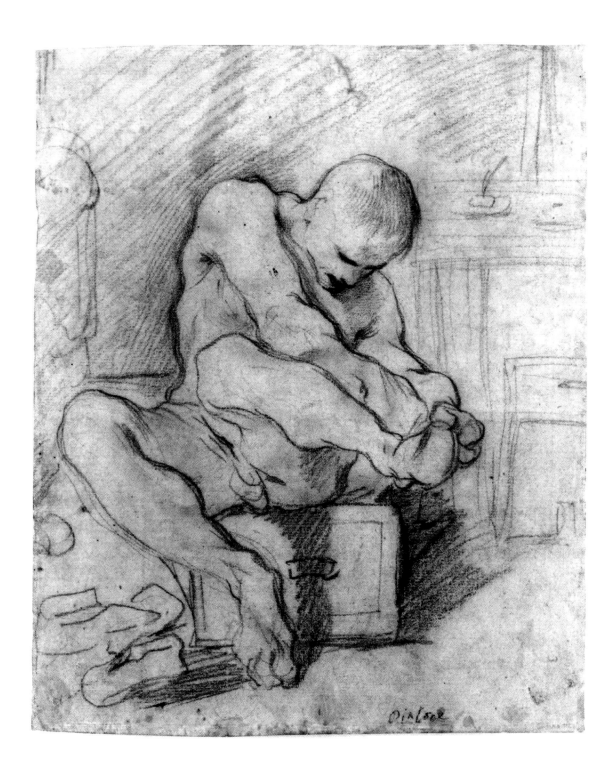

45. Ferraù Fenzoni (Italian, 1562-1645)
Study of a Seated Nude, ca. 1590
Red chalk, on buff laid paper
10 15/16 x 9 1/8 in.(27.8 x 23.2 cm)
Milwaukee Art Museum; Max E. Friedmann—Elinore Weinhold Friedmann Bequest M1954.20

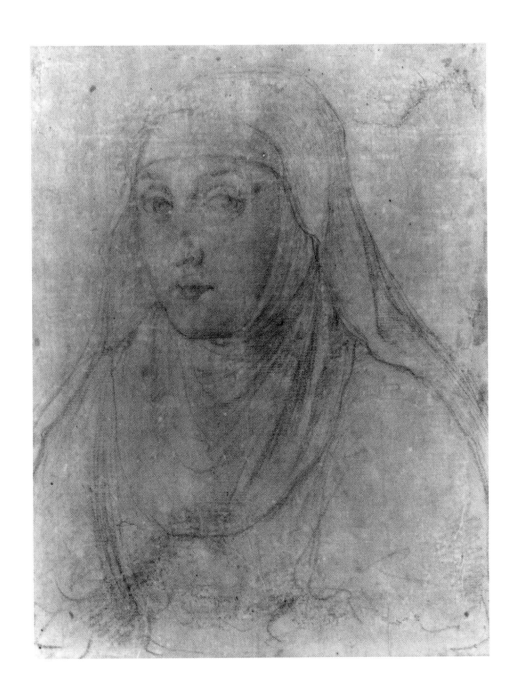

46. Florentine, 16th century
Head of a Woman, mid- to late 16th century
Red chalk, on buff laid paper
9 3/4 x 7 5/8 in. (24.8 x 19.4 cm)
Milwaukee Art Museum; gift of Mrs. Albert T. Friedmann M1950.43

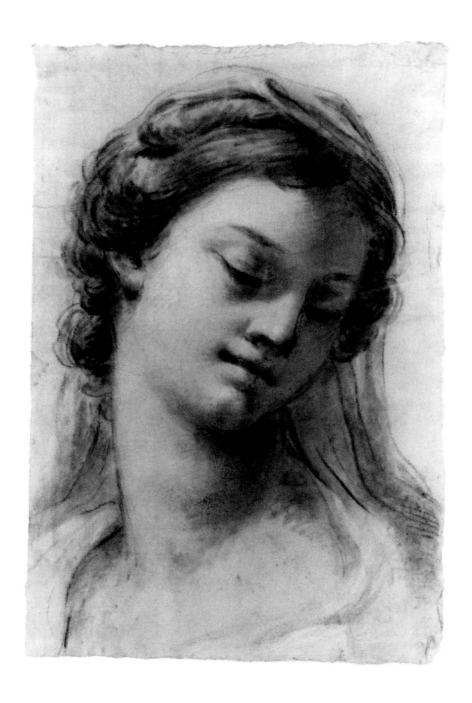

47. Attributed to **Gaetano Gandolfi** (Italian, 1739-1802)
Head of a Woman
Charcoal, black chalk, with white chalk highlights, on buff laid paper
12 1/8 x 8 1/2 in. (30.8 x 21.6 cm)
Milwaukee Art Museum; Max E. Friedmann—Elinore Weinhold Friedmann Bequest M1954.25

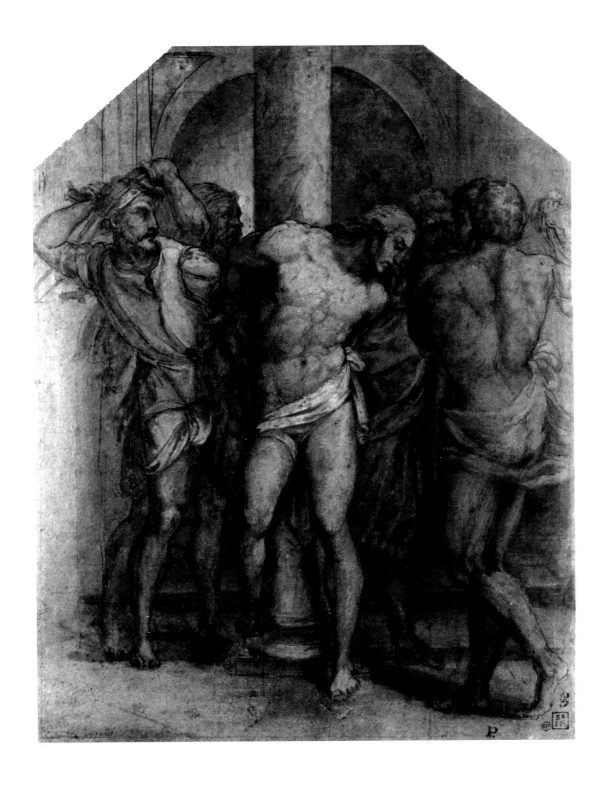

48. Attributed to **Adamo Ghisi,** called **Scultori** (Italian, ca. 1530-1585)
Scourging of Christ
Brown wash with white highlights, on blue-green paper
14 x 11 1/16 in. (35.6 x 28.1 cm)
Elvehjem Museum of Art, University of Wisconsin—Madison; gift of Miss Charlotte C. Gregory 64.15.8

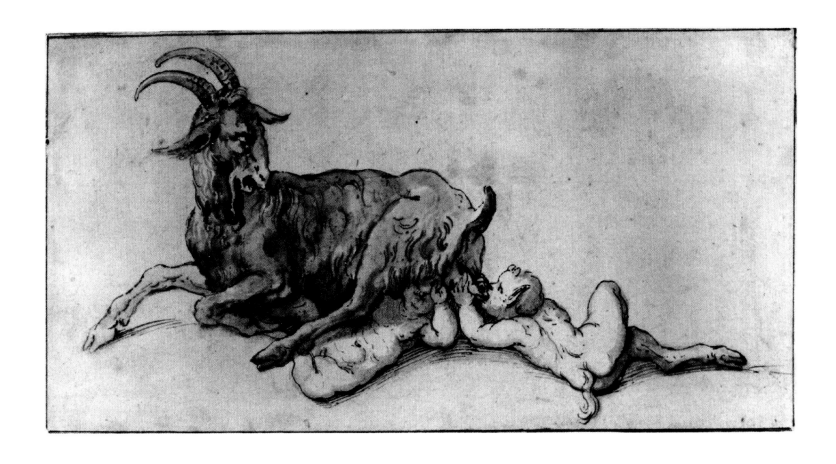

49. **Giulio Pippi,** called **Giulio Romano** (Italian, 1499-1546)
She-Goat Nursing Two Faun Children, ca. 1525-28
Quill pen and bistre ink wash, on paper
8 9/16 x 13 5/16 in. (21.7 x 33.8 cm)
Elvehjem Museum of Art, University of Wisconsin—Madison; Anonymous Funds purchase 1973.147

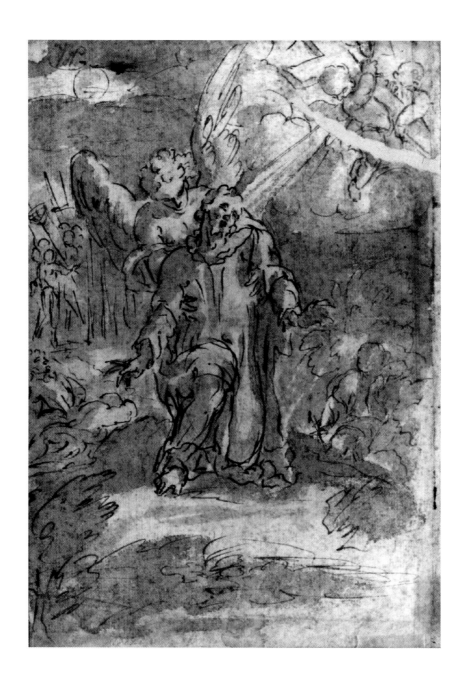

50. **Jacopo Palma,** called **Palma Giovane** (Italian, 1544-1628)
Agony in the Garden (recto)
Pen and black ink with brown wash over black chalk, on cream paper
8 x 5 5/8 in. (20.3 x 14.3 cm)
Milwaukee Art Museum; Max E. Friedmann—Elinore Weinhold Friedmann Bequest M1954.21b

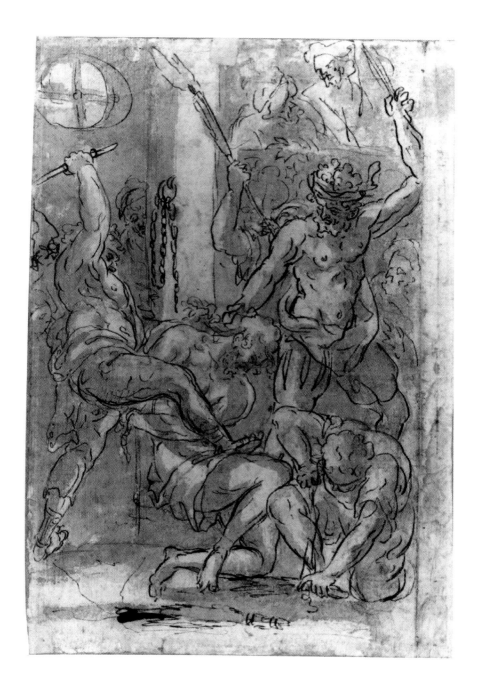

51. **Jacopo Palma,** called **Palma Giovane** (Italian, 1544-1628)
The Flagellation of Christ (verso)
Pen and black ink with brown wash over black chalk, on cream paper
8 x 5 5/8 in. (20.3 x 14.3 cm)
Milwaukee Art Museum; Max E. Friedmann—Elinore Weinhold Friedmann Bequest M1954.21a

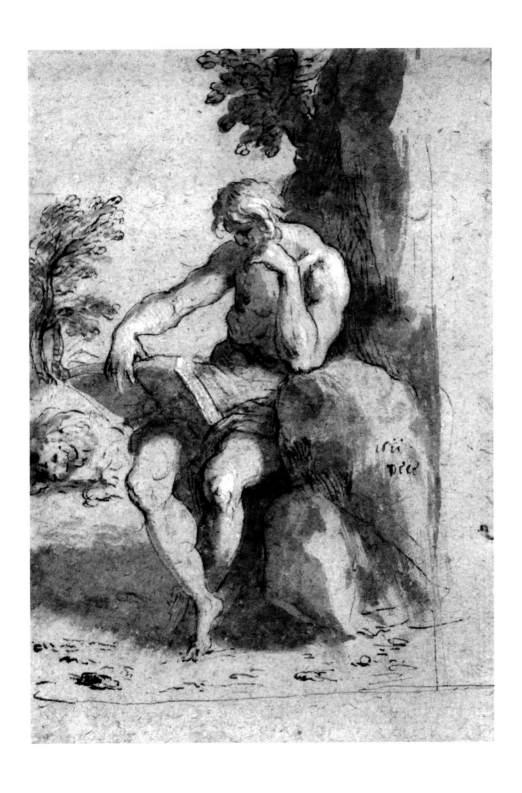

52. **Jacopo Palma,** called **Palma Giovane** (Italian, 1544-1628)
St. Jerome
Pen and sepia ink and wash, on tan paper
8 x 5 1/2 in. (20.3 x 14 cm)
Collection of Esther Leah Ritz

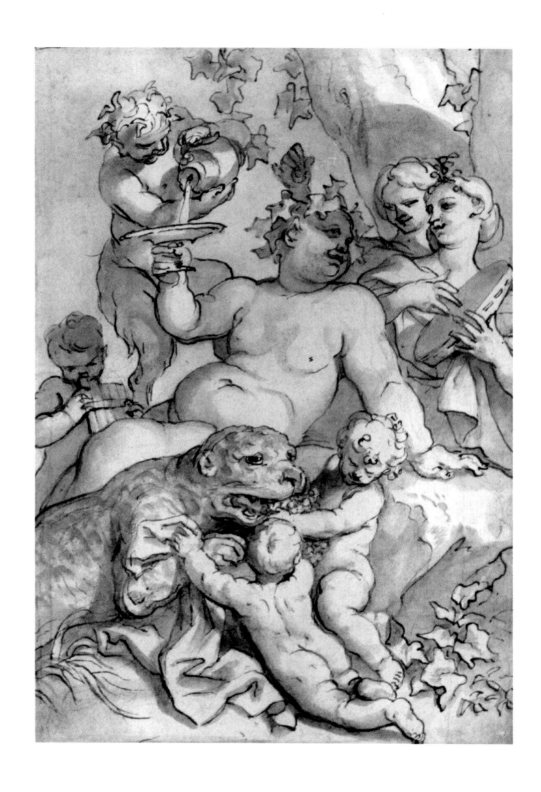

53. **Domenico Piola** (Italian, 1627-1703)
Bacchus and His Attendants
Pen and brown ink with brown wash over graphite, on cream laid paper
10 3/8 x 7 3/8 in. (26.4 x 18.7 cm)
Milwaukee Art Museum; Max E. Friedmann—Elinore Weinhold Friedmann Bequest M1954.59

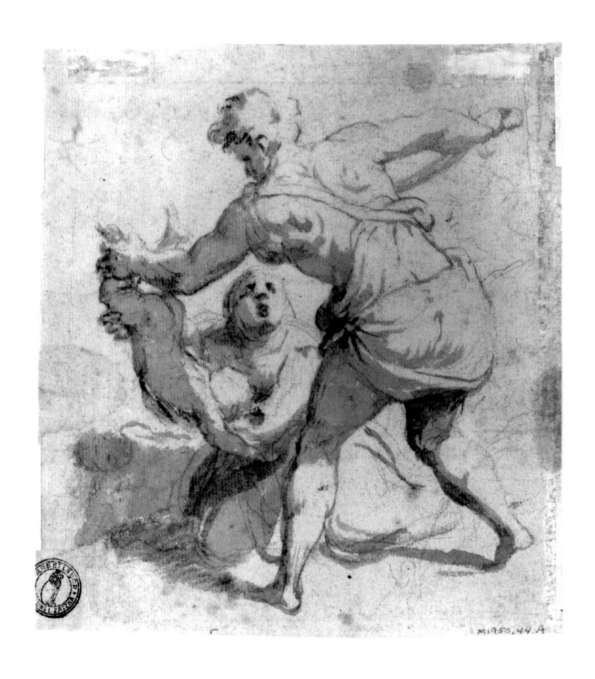

54. Roman, 16th century
Figure Study for a Massacre of the Innocents (recto), late 16th century
Brown wash over black chalk, on cream laid paper
7 1/2 x 6 15/16 in. (19.1 x 17.6 cm)
Milwaukee Art Museum; gift of Mrs. Albert T. Friedmann M1950.44a

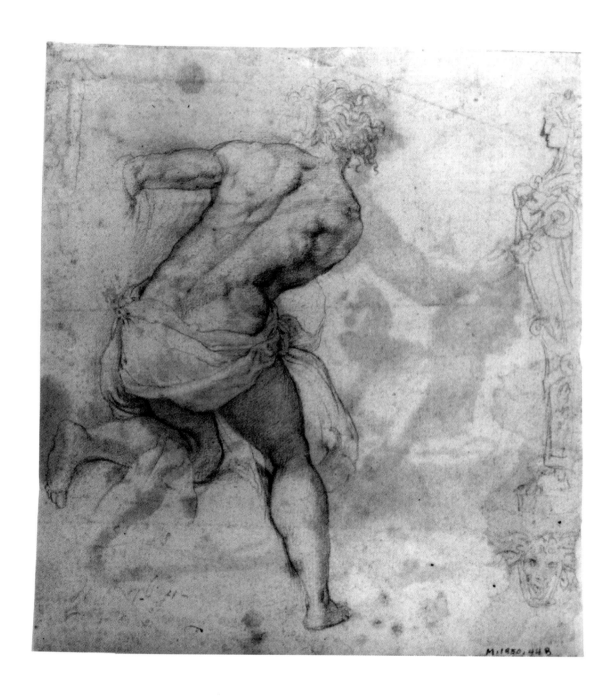

55. Roman, 16th century
Figure Study for a Massacre of the Innocents (verso), late 16th century
Black chalk, on cream laid paper
7 1/2 x 6 15/16 in. (19.1 x 17.6 cm)
Milwaukee Art Museum; gift of Mrs. Albert T. Friedmann M1950.44b

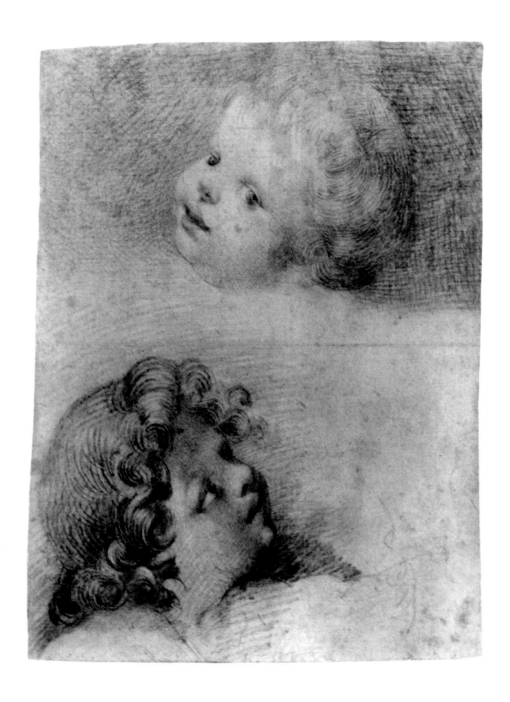

56. **Cristoforo Roncalli,** called **Il Pomarancio** (Italian, 1552-1626)
Two Heads of Children
Black and red chalk, on paper
8 1/2 x 6 1/8 in. (15.6 x 21.6 cm)
Private collection

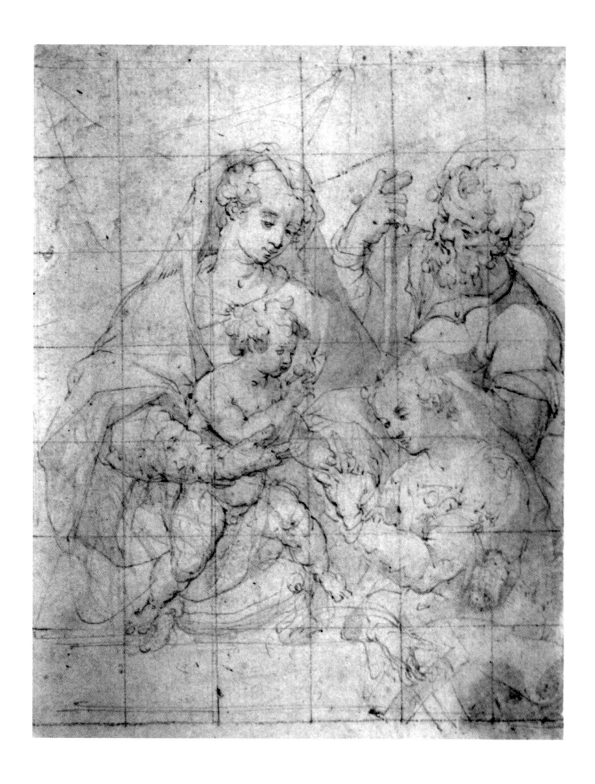

57. Attributed to **Orazio Samacchini** (Italian, 1532-1577)
The Mystic Marriage of St. Catherine of Alexandria, ca. 1570
Pen and brown ink with brown wash over charcoal and red chalk, squared with red chalk, on cream laid paper
5 7/8 x 4 5/8 in. (14.9 x 11.7 cm)
Milwaukee Art Museum; Max E. Friedmann—Elinore Weinhold Friedmann Bequest M1954.27

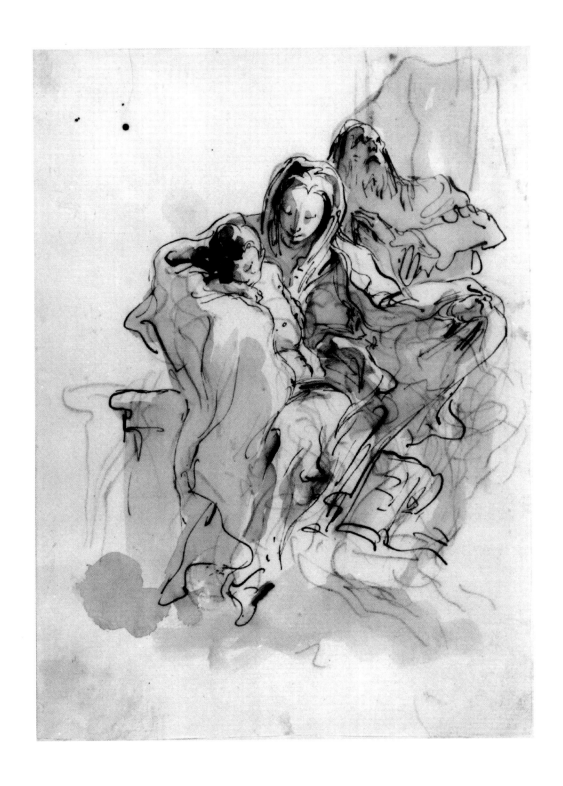

58. **Giovanni Battista Tiepolo** (Italian, 1696-1770)
The Holy Family, ca. 1759-60
Quill pen and bistre ink and wash over black chalk, on paper
10 3/4 x 8 1/8 in. (27.3 x 20.6 cm)
Elvehjem Museum of Art, University of Wisconsin—Madison; Oscar Rennebohm Foundation Fund purchase 65.4.1

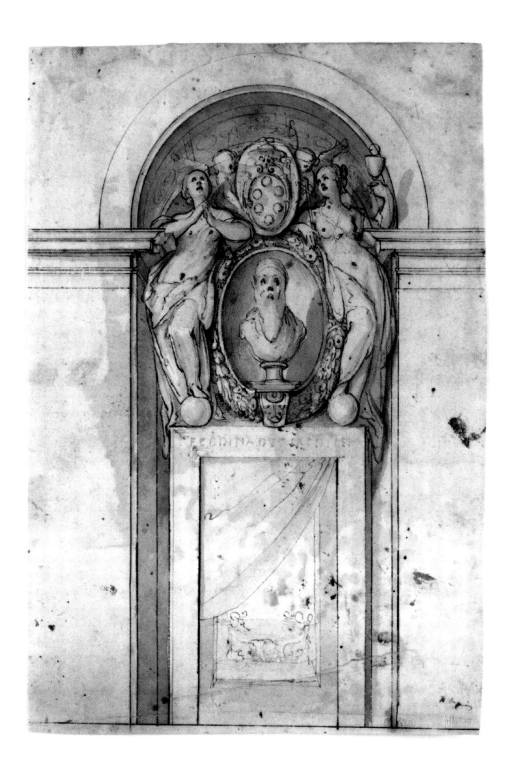

59. Federico Zuccaro (Italian, 1540-1609)
Design for a Monument to Ferdinando I
Pen and brown ink with brown wash over charcoal, on cream wove paper
12 11/16 x 8 11/16 in. (32.2 x 22.1 cm)
Milwaukee Art Museum; gift of Fine Arts Society, Virginia M. Clark, Mr. and Mrs. Frederick Fairchild Hansen, and Arthur and Nancy Laskin M1990.87

PHOTOGRAPHY CREDITS

Pls. 12, 13, 18, 23, 24: ©1996, The Art Institute of Chicago. All rights reserved.

Pls. 9, 15, 16, 20, 22, 25, 26, 38, 39, 40, 48, 49, 58: ©Elvehjem Museum of Art, University of Wisconsin—Madison.

Pl. 17: Courtesy The Patrick and Beatrice Haggerty Museum of Art, Marquette University.

Copyright ©1997, Milwaukee Art Museum.
Pls. 36, 37, 41, 42, 52: Efraim Lev-er
Pls.: 1-8, 10, 11, 14, 19, 21, 27-35, 43-47, 50, 51, 53-57, 59: Larry Sanders